O9-AHW-925

MEANWHILE in SAN FRANCISCO

THE CITY in ITS OWN WORDS

WENDY MacNAUGHTON

CHRONICLE BOOKS

SAN FRANCISCO

Text and illustrations copyright © 2014
by Wendy MacNaughton.

All rights reserved. No part of this book may be reproduced
in any form without written permission from the publisher.

Library of Congress Cataloging-in-Publication Data available.

ISBN: 978-1-4521-1389-0

Manufactured in China.

Design by Alice Chau
Production assistance by DC Typography

10 9 8 7

Chronicle Books LLC
680 Second Street
San Francisco, CA 94107
www.chroniclebooks.com

MEANWHILE
in
SAN FRANCISCO

THE FOG
↙

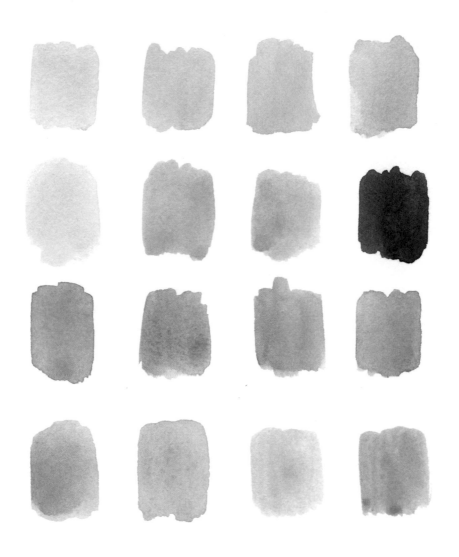

SAMPLE *of* SF SKIES

CONTENTS

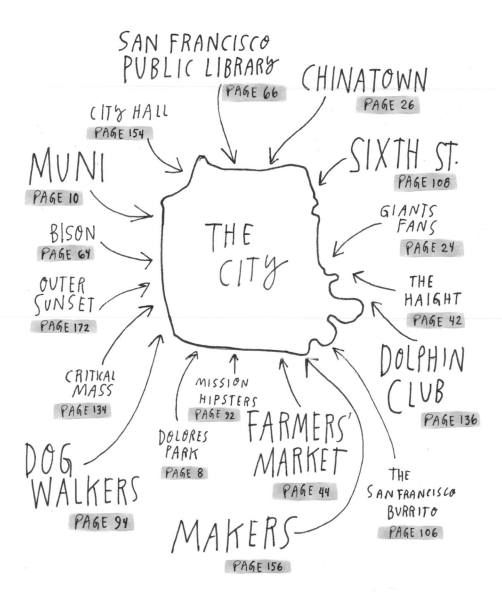

PAINT BRUSH
in COFFEE
by MISTAKE.
AGAIN.

INTRODUCTION

These stories are a collaboration. The drawings are mine,
but the words came from people living and working in
San Francisco.

To create each story, I spent anywhere from twenty-four
hours to four weeks getting to know the people, the place,
and their histories through conversation and observation.
All the while I drew everything I noticed; sometimes I worked
from photos, but mostly from life. Drawing on location helps
me notice things I'd otherwise overlook, and often serves as
an introduction to those I'd otherwise never meet. People
are often put off by a stranger with a camera in their neigh-
borhood, but when they see someone standing on a street
corner drawing with pen on a pad of paper, they stop. They
ask what I'm doing, and a conversation starts. The twenty to
thirty different people I spoke with for each story were com-
bined into one voice that represents the group.

This book is by no means intended as a comprehensive
portrayal of San Francisco. It's only a small handful of the
huge number of communities to be found in The City, on
every steep street, behind every gated door, in every grassy
park. These are the stories of San Francisco daily life. This
is what happens in the meanwhile.

WENDY MACNAUGHTON

DOLORES

THE BENCH GAY TOURISTS TAKING PHOTOS THE BUSHES = CRUISING →

THE VIEW v TRUFFLE GUY

TOURISTS GAWKING → **THE BEACH** ← - - - → GAY BEACH LITE EARLY BIRD BBQS

A·K·A· FAIRY PRAIRIE

NAKED* GUYS - - - - - - - - HALF NAKED GUYS (BEST SEAT in THE HOUSE)

*NEARLY

MEDIUM-SIZED DOGS

TRUFFLE GUY

COLD BEER, COLD WATER, COLD BEER, COLD WATER, COLD BEER, COLD WATER, COLD BEER, COLD WATER, COLD BEER, COLD WATER, COLD BEER, COLD WATER, COLD BEER, COLD WATER, COLD BEER, COLD WATER, COLD BEER, COLD WATER, COLD BEER, COLD WATER, COLD BEER, COLD WATER, COLD BEER, COLD WATER, COLD BEER, COLD WATER...

BENCHES

SLEEPING

SERIOUS CONVERSATIONS (BREAK-UPS)

CREEPY LURKING DUDE (BEWARE KIDS.)

→ RUNAWAY KIDS

→ **LESBIANS** ←

SO. MANY. KIDS.

BUTCH, FEMME, YOUNG, OLD ALL CHECKING OUT THE ↘

R.I.P. OLD PIRATE SHIP

LITTLE LESBIAN DOGS FAMILIES THE ENDLESS LINE for THE BATHROOM (WOMEN'S)

BIKINIS

KIDS!

PICNICS, CRAFT BEER, WINE → BASKETS of ♪

MORE BREAK-UPS and FIRST-TIMERS

STROLLERS → **FAMILIES** ← ARTISANAL LOCAL MEATS and HOME-MADE ICE CREAM

...STROLLERS NO SMELL of WEED.

SMELL of WEED

HOOPERS ...MORE STROLLERS.

SOMEONE TRYING to FLY A KITE

CIRCUS CAMP ...STILL MORE STROLLERS!

SLACK ROPE ACOUSTIC GUITARS !

STEEP PART of HILL FASCINATED KIDS. CONFUSED ADULTS. NON-SMOKING SECTION

B T

* PLEASE NOTE THIS IS AN APPROXIMATE, EVER-EVOLVING
LOOK DIFFERENT· THAT'S COOL· FEEL FREE to USE A

PARK*

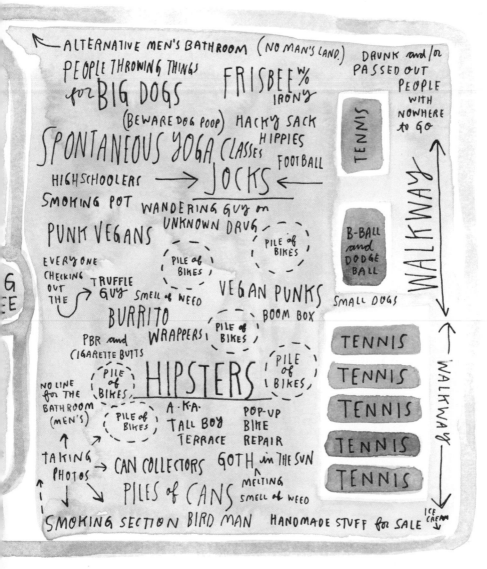

ALTERNATIVE MEN'S BATHROOM (NO MAN'S LAND.)
DRUNK and/or PASSED OUT PEOPLE WITH NOWHERE TO GO

PEOPLE THROWING THINGS for BIG DOGS

FRISBEE w/ IRONY

(BEWARE DOG POOP) HACKY SACK

SPONTANEOUS YOGA CLASSES
HIPPIES
FOOTBALL

HIGHSCHOOLERS → JOCKS ←

SMOKING POT WANDERING GUY on UNKNOWN DRUG

PUNK VEGANS

PILE of BIKES

EVERYONE CHECKING OUT THE → TRUFFLE GUY

PILE of BIKES

SMELL of WEED

VEGAN PUNKS

BURRITO WRAPPERS
PILE of BIKES
BOOM BOX

PBR and CIGARETTE BUTTS

NO LINE for THE BATHROOM (MEN'S)

PILE of BIKES

PILE of BIKES

HIPSTERS

PILE of BIKES

A.K.A. TALL BOY TERRACE

POP-UP BIKE REPAIR

TAKING PHOTOS → CAN COLLECTORS GOTH in THE SUN

PILES of CANS
MELTING
SMELL of WEED

SMOKING SECTION BIRD MAN HANDMADE STUFF for SALE

ICE CREAM

TENNIS

B-BALL and DODGE BALL

SMALL DOGS

WALKWAY

TENNIS
TENNIS
TENNIS
TENNIS
TENNIS

WALKWAY

MAP. IT'S HIGHLY LIKELY <u>YOUR</u> DOLORES PARK MAP MAY
PEN and ALTER IT AS YOU SEE FIT. IN SF, WE'RE ALL RIGHT. RIGHT?

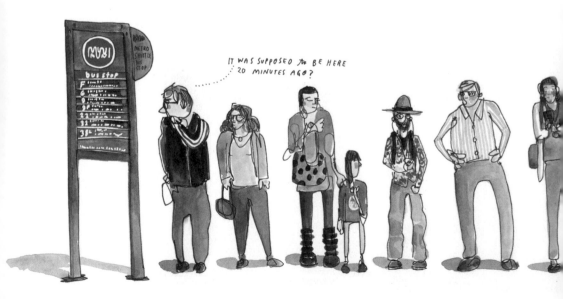

IN ITS OWN WORDS

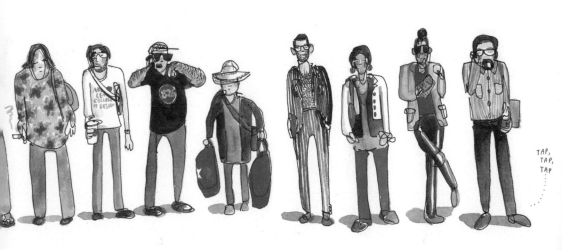

5.45 - 5.49 A.M.

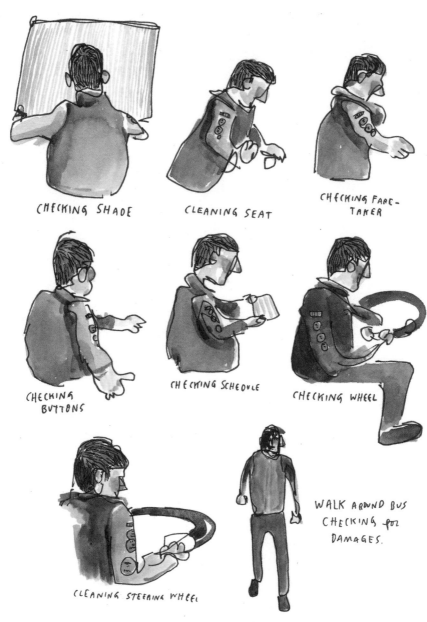

CHECKING SHADE

CLEANING SEAT

CHECKING FARE-TAKER

CHECKING BUTTONS

CHECKING SCHEDULE

CHECKING WHEEL

CLEANING STEERING WHEEL

WALK AROUND BUS CHECKING for DAMAGES.

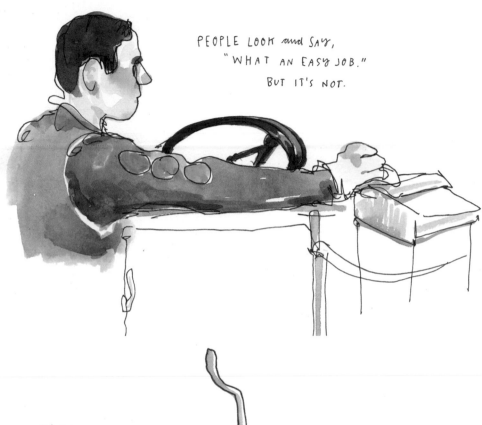

PEOPLE LOOK and SAY,
"WHAT AN EASY JOB."
BUT IT'S NOT.

5:52 A.M.

FIRST
PASSENGER

NOW WE ARE in
SERVICE

OVER A TWO HOUR PERIOD:

NUMBER of TIMES SOMEONE SAID HELLO: 17
NUMBER of TIMES SOMEONE SAID THANK YOU: 5
NUMBER of PASSENGERS: APPROX. 300

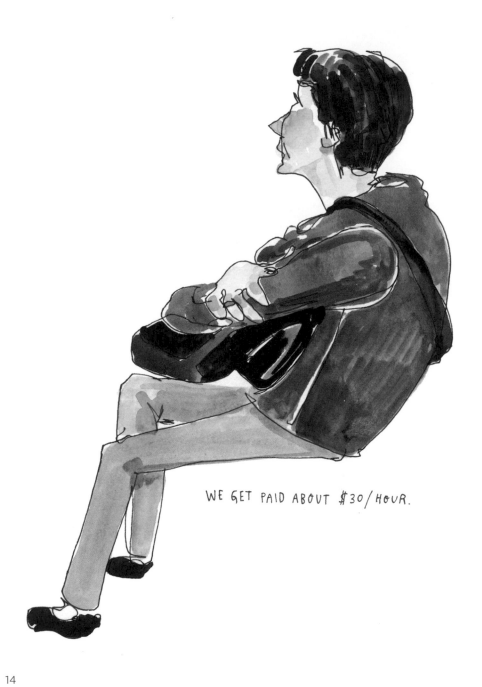

WE GET PAID ABOUT $30/HOUR.

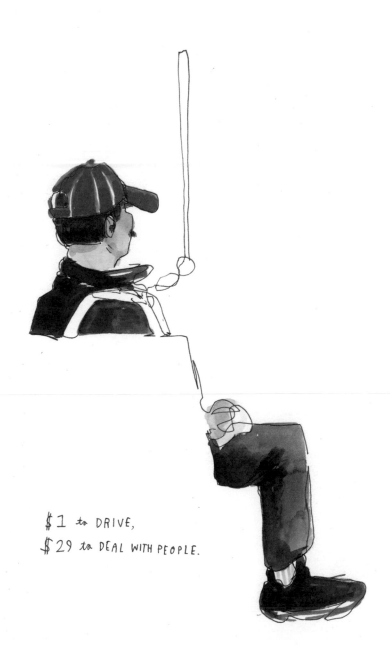

$1 to DRIVE,
$29 to DEAL WITH PEOPLE.

WHERE YOU DRIVE DETERMINES WHO YOU DRIVE.

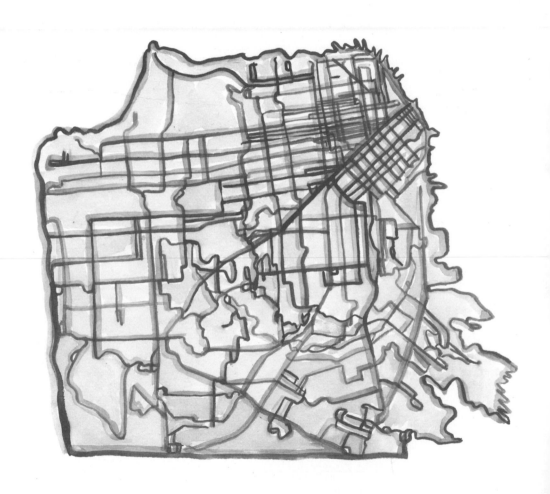

ALL THE BUS LINES in SF

ON THE 38 IT'S MOSTLY WHITE and ASIAN,
in THE MISSION IT'S MOSTLY LATINO.
BAYVIEW IS MOSTLY AFRICAN-AMERICAN.

SAN FRANCISCO IS PRETTY DIVIDED LIKE THAT.

MY KIDS WON'T TAKE THE BUS.

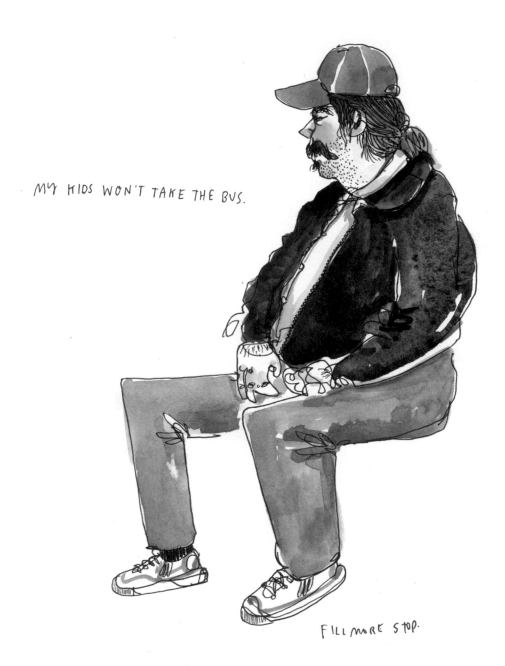

FILLMORE STOP.

THEY SAY IT SMELLS.

LUNCH

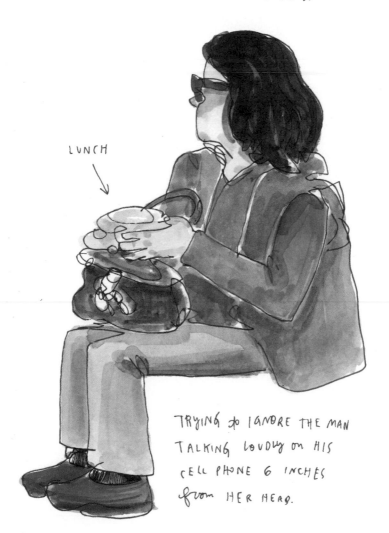

TRYING to IGNORE THE MAN
TALKING LOUDLY on HIS
CELL PHONE 6 INCHES
from HER HEAD.

BUT I LIKE THE INTERACTION
WITH PEOPLE,

ALL THE DIFFERENT CULTURES.

I HAVE THE FIRST CLASS SEAT.

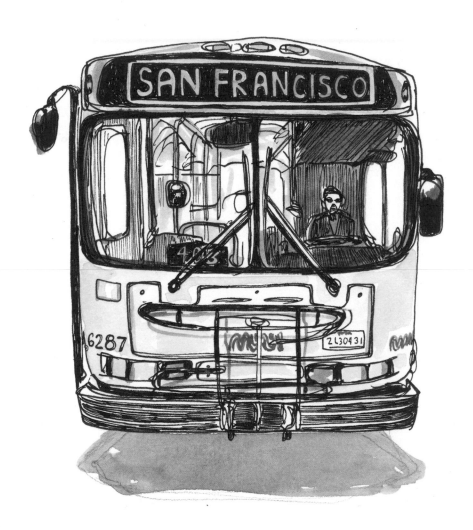

MEANWHILE...

SAN FRANCISCO
GIANTS
FANS

CARLOS
WHO STARTS
THE CHANTING
IN THE BAR

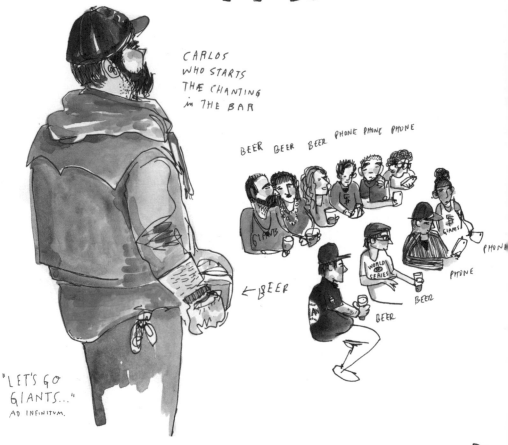

BEER BEER BEER PHONE PHONE PHONE

←BEER

BEER

PHONE

PHONE

BEER

BEER

"LET'S GO
GIANTS..."
AD INFINITUM.

22 KAYAKS, 6 MOTORBOATS, 1 ROWBOAT

COCOBELLA

THE LITTLEST BIG FAN

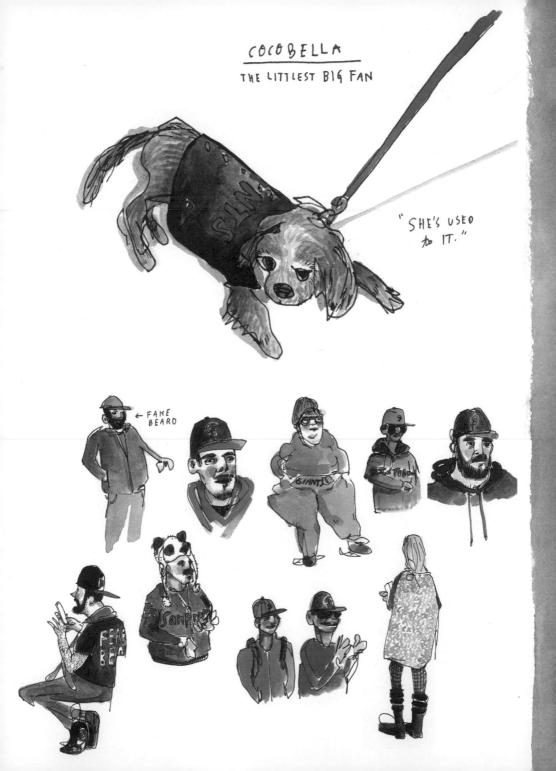

"SHE'S USED to IT."

← FAKE BEARD

CHINATOWN

in ITS OWN WORDS

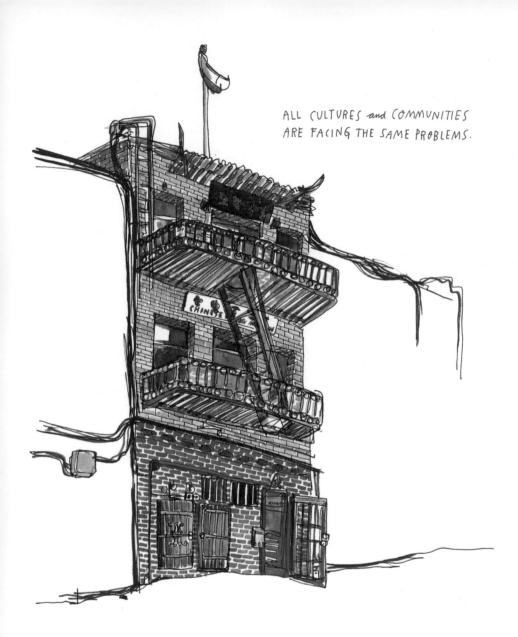

ALL CULTURES and COMMUNITIES
ARE FACING THE SAME PROBLEMS.

NEW GENERATIONS WANT *To* MAKE LIFE BETTER.

OLD GENERATIONS DON'T WANT *to* CHANGE.

PEOPLE GRAVITATE TOWARD PEOPLE
in THEIR OWN CULTURE and LANGUAGE
SO THEY DON'T FEEL OUT of PLACE.

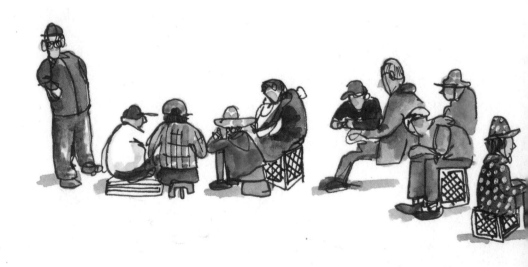

PEOPLE WANT to SEE FAMILIAR FACES.

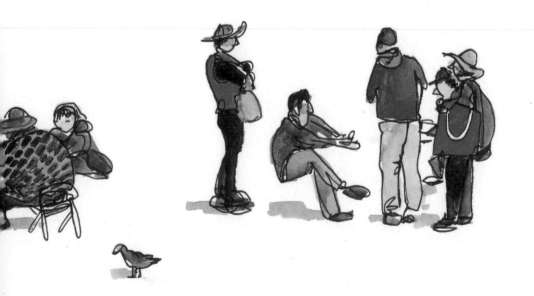

EVERY CULTURE HAS THEIR OWN WAY
of ENTERTAINING THEMSELVES.

THE PARK

3 P.M. on A TUESDAY

44 GAMES GOING ON

PAI GOW
CHINESE CHESS
AMERICAN CHESS
13 CARD POKER
8 CARD POKER

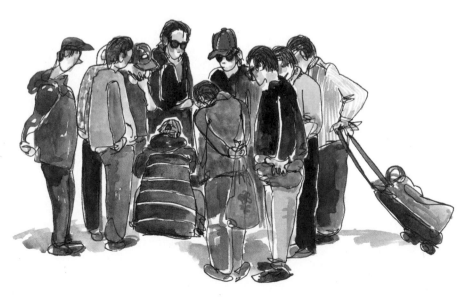

PEOPLE PLAY for MONEY.
FIVE DOLLARS, TEN DOLLARS
IS A LOT for SOME PEOPLE.
IT'S EXCITEMENT.

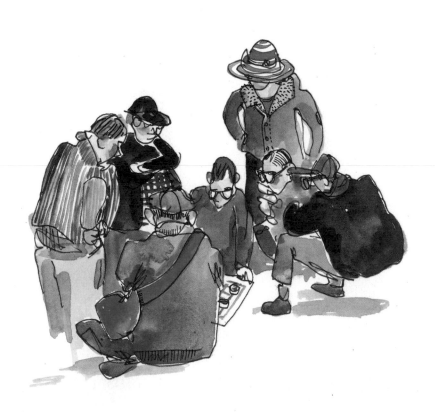

SOME ARE PASSING TIME
WAITING ~~for~~ FAMILY,
for LITTLE CHILDREN,
or AFTER SHOPPING.

MAH JONG IS MORE PRIVATE.

MAH JONG HOUSE A.

SECURITY CAMERA ↑

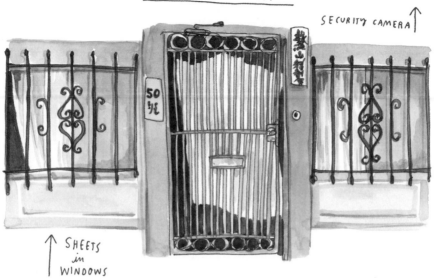

↑ SHEETS in WINDOWS

MAH JONG HOUSE B.

LOCKED GATES

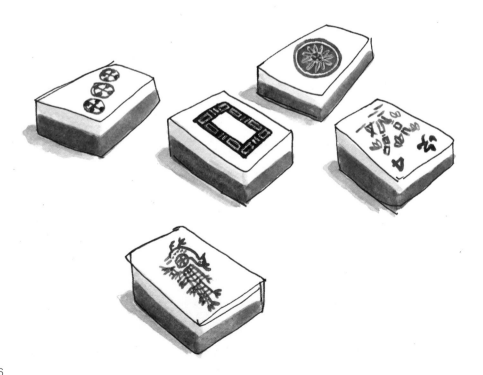

PEOPLE ARE MORE SERIOUS.

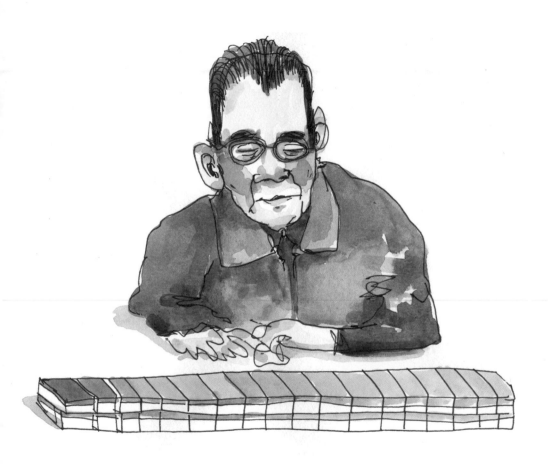

THEy WIN and LOSE A LOT of MONEY.

THE CITY THINKS IT'S BAD,
THINKS THAT CRIME IS INVOLVED,
BUT IT'S NOT LIKE THAT.

IT'S ENTERTAINMENT.
IT'S A SOCIAL CLUB.
IT'S A COMMUNITY CENTER.

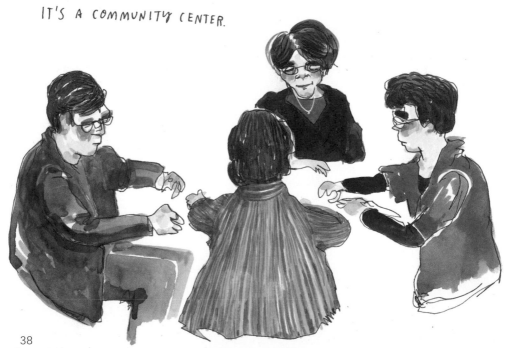

THE GAMES ARE A BIG PART of
CHINESE CULTURE — A BIG PART of
CHINATOWN.

EVENTUALLY THIS PLACE IS GOING to CHANGE.

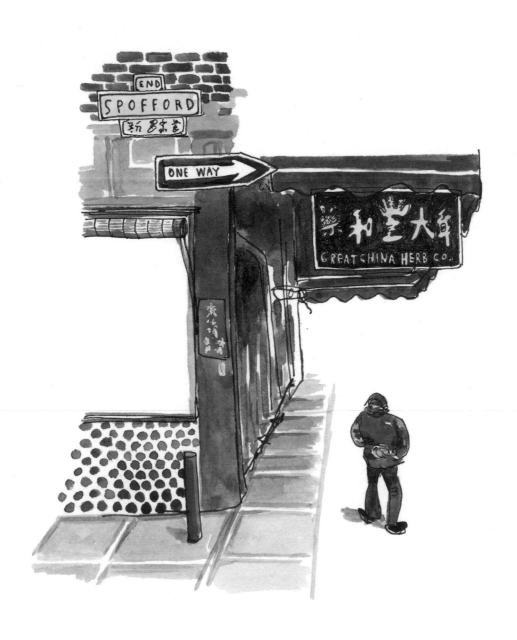

BUT NOT VERY SOON.

MEANWHILE...

THE HAIGHT

← LOWER HAIGHT

← TATTOOS
← HIPSTER-PUNKS
← COFFEE SHOPS
← LOST TOURISTS
← LITTLE DOGS
← FOREARM TATTOOS

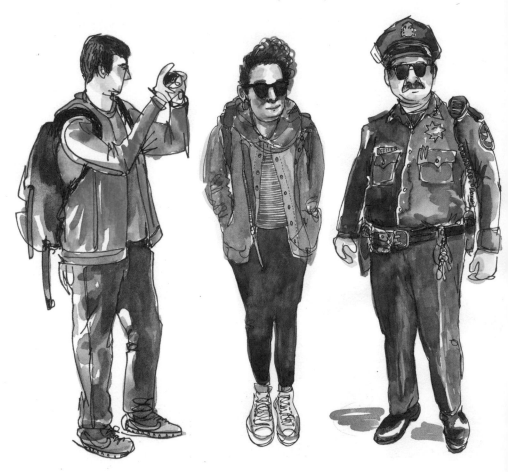

UPPER HAIGHT ——→

TIE-DYES ——→
HIPPIE-PUNKS ——→
THRIFT STORES ———→
TOURISTS ——→
BIG DOGS ———→
FACE TATTOOS ——→

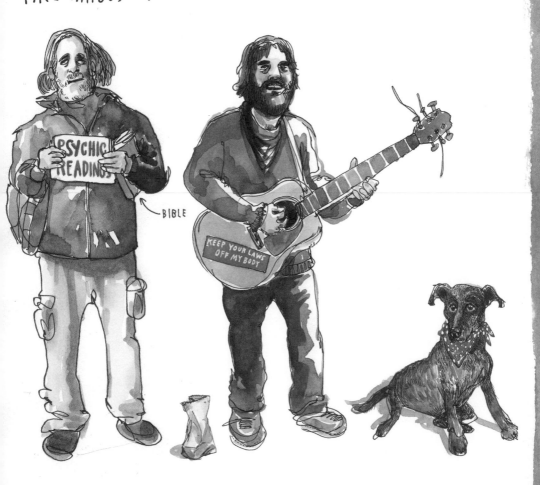

PSYCHIC READINGS

←— BIBLE

KEEP YOUR LAWS OFF MY BODY

SAN FRANCISCO CIVIC CENTER
FARMERS' MARKET

IN ITS OWN WORDS

THE VENDORS COME FROM ALL OVER.

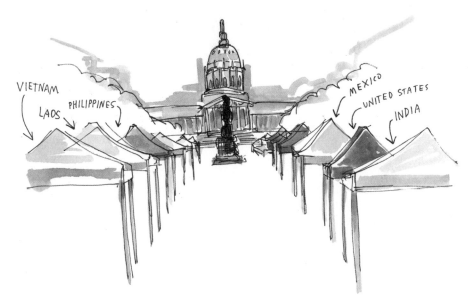

VIETNAM
LAOS
PHILIPPINES
MEXICO
UNITED STATES
INDIA

OUR FAMILY CAME FROM VIETNAM in 1979.

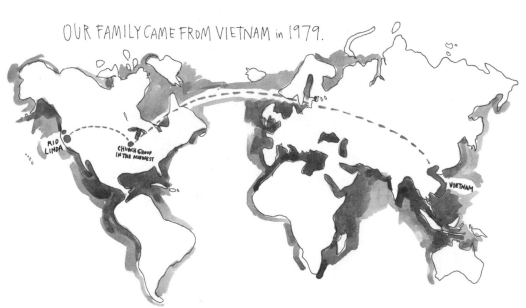

RIO LINDA
CHURCH GROUP IN THE MIDWEST
VIETNAM

WE WERE THE FIRST ASIAN FAMILY IN RIO LINDA. *

* DO YOU KNOW ABOUT RIO LINDA?
THERE WERE LOTS OF KKK.

THE FAMILY

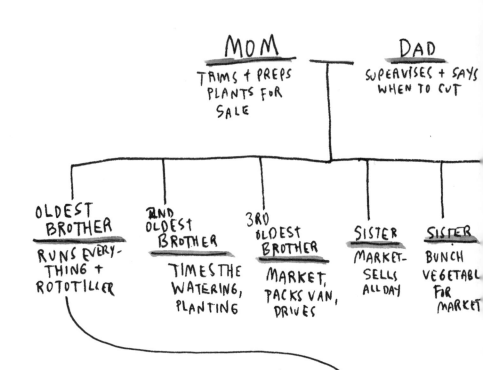

MOM
TRIMS + PREPS
PLANTS FOR
SALE

DAD
SUPERVISES + SAYS
WHEN TO CUT

OLDEST
BROTHER
RUNS EVERY-
THING +
ROTOTILLER

2ND
OLDEST
BROTHER
TIMES THE
WATERING,
PLANTING

3RD
OLDEST
BROTHER
MARKET,
PACKS VAN,
DRIVES

SISTER
MARKET-
SELLS
ALL DAY

SISTER
BUNCH
VEGETABL
FOR
MARKET

EVERYONE MEETS AT THE HOUSE
THE DAY BEFORE MARKET (SATURDAY IN SUMMER)
TO WORK, SPENDS THE WHOLE DAY WORKING.
(* NOTE: ALL SIBLINGS HAVE A SECOND, FULL-TIME JOB.)

BUSINESS*

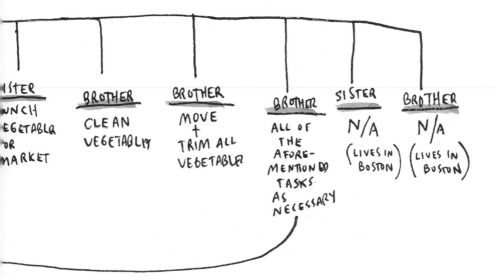

ISTER
UNCH
EGETABLE
OR
MARKET

BROTHER
CLEAN
VEGETABLE

BROTHER
MOVE
+
TRIM ALL
VEGETABLE

BROTHER
ALL OF
THE
AFORE-
MENTIONED
TASKS
AS
NECESSARY

SISTER
N/A
(LIVES IN
BOSTON)

BROTHER
N/A
(LIVES IN
BOSTON)

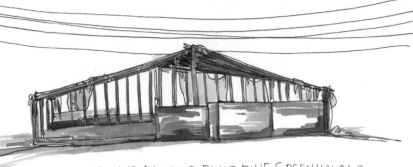

MY DAD AND BROTHER BUILT FIVE GREENHOUSES.

MY BROTHER CHANGES THE WATER.

MY OTHER BROTHER CUTS EVERYTHING.

MY OTHER BROTHER LOADS EVERYTHING.

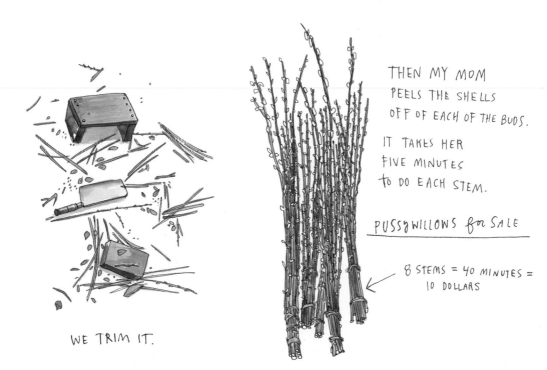

WE TRIM IT.

THEN MY MOM PEELS THE SHELLS OFF OF EACH OF THE BUDS.

IT TAKES HER FIVE MINUTES TO DO EACH STEM.

PUSSYWILLOWS for SALE

8 STEMS = 40 MINUTES = 10 DOLLARS

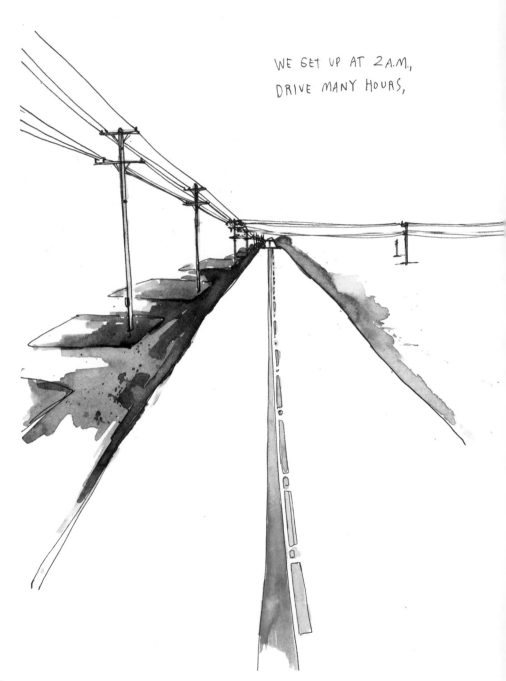

WE GET UP AT 2 A.M.,
DRIVE MANY HOURS,

AND SET UP EVERYTHING
FOR THE EARLY CUSTOMERS.

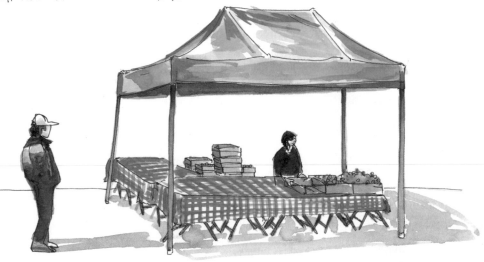

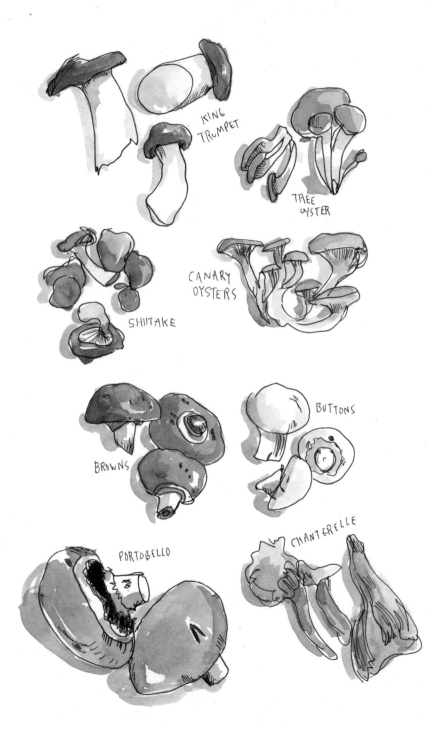

KING
TRUMPET

TREE
OYSTER

CANARY
OYSTERS

SHIITAKE

BROWNS

BUTTONS

PORTOBELLO

CHANTERELLE

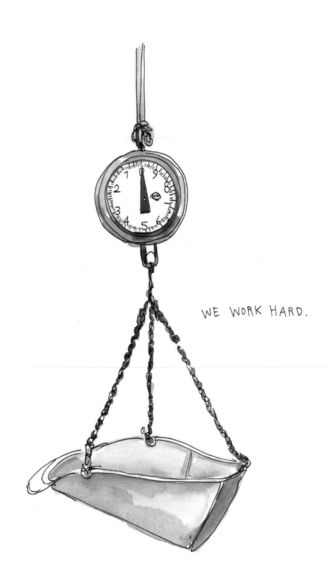

WE WORK HARD.

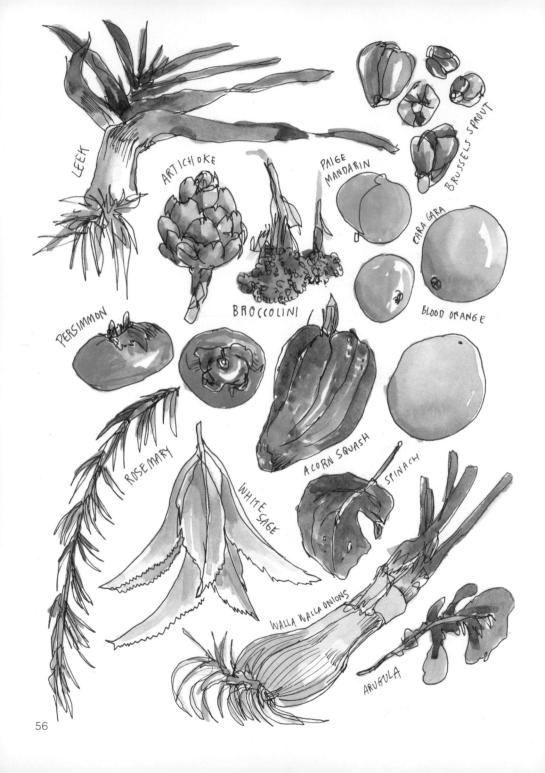

LEEK

ARTICHOKE

PAIGE MANDARIN

BRUSSELS SPROUT

CARA CARA

BROCCOLINI

BLOOD ORANGE

PERSIMMON

ROSEMARY

WHITE SAGE

ACORN SQUASH

SPINACH

WALLA WALLA ONIONS

ARUGULA

56

IT USED TO BE TOUGH HERE.

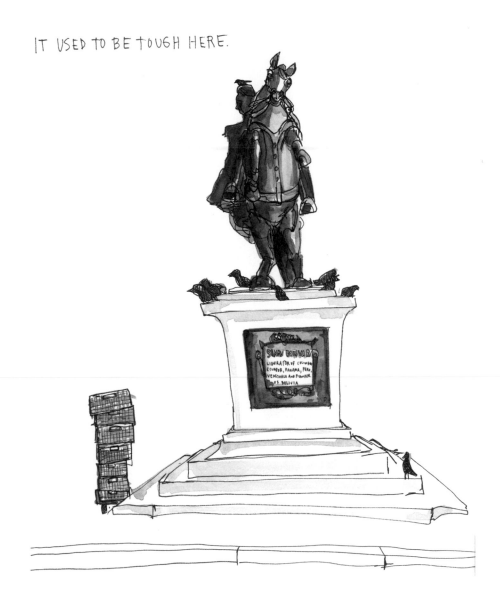

BUT WE TAKE CARE OF EACH OTHER.
GIVE IOUs.
HIRE THE HOMELESS TO HELP LOAD + UNLOAD.
HELP THE OLDER PEOPLE.

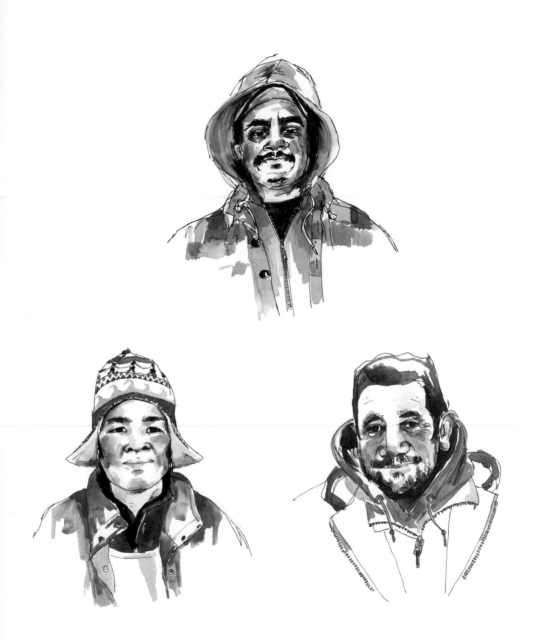

IT'S LIKE A FAMILY.

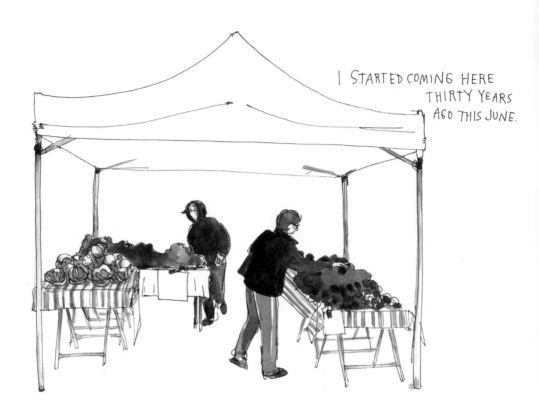

I STARTED COMING HERE THIRTY YEARS AGO THIS JUNE.

I SAID I'D STAY A YEAR.

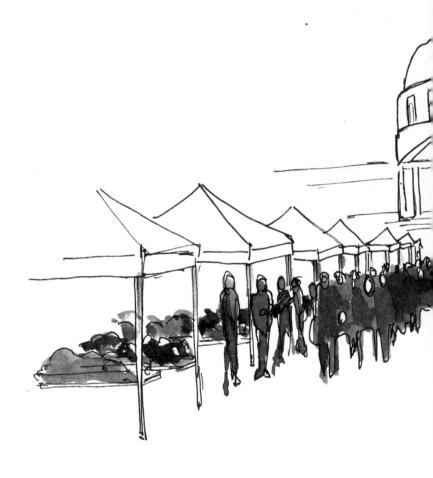

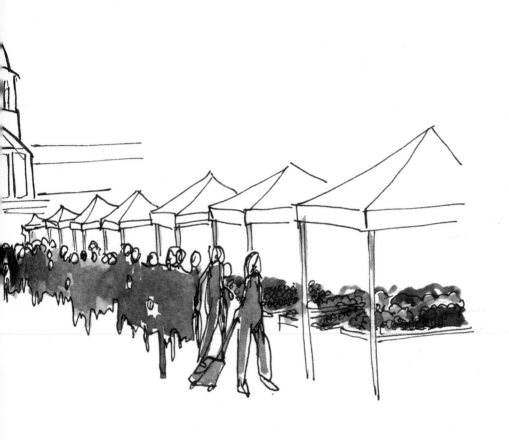

I'VE BEEN HERE EVER SINCE.

MEANWHILE...

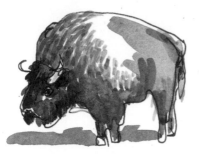

BROOMHILDA.**

THE BISON
of
GOLDEN GATE PARK
—ARRIVED 1890—

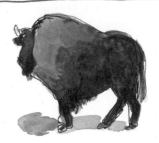

BELLATRIX**

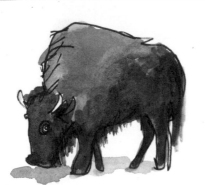

BETSY**

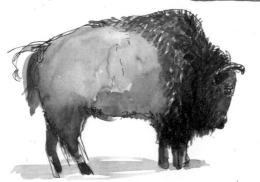

UNNAMED COW ("U.C.")

* SPECIAL NOTE: U.C. WAS A GIFT from DIANNE FEINSTEIN'S HUSBAND ABOUT 30 YEARS AGO.

THERE USED to BE 60 MILLION BISON ROAMING THE U.S. PLAINS, UNTIL WHITE PEOPLE, GUNS, TRAINS ARRIVED. BISON WE KILLED for SPORT UNTIL ON 1,000 WERE LEFT. THEY BECAME A PROTECTED SPEC and NOW THERE ARE 500,000 LIVING in PRIVATE PRESERVES and PLACES LIKE YELLOWSTON

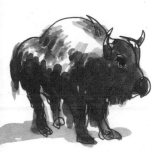

BAILEY ✳✳

DAILY ROUTINE:
GRAZE
RUMINATE
EAT GAAIN
GRAZE
SLEEP
REPEAT

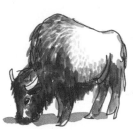

BUTTERCUP ✳✳

✳ = OLD LADY
✳✳ = LITTLE GIAL
NO BULLS (NO FUN to WORK WITH)
~OLD LADIES AUN THE SHOW
MPT. NOTE: BISON ≠ BUFFALO

ANOTHER "B" NAME BUT I CAN'T REMEMBER ✳✳

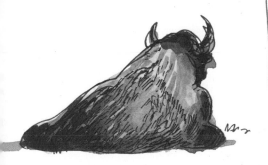

LAST COW ("L.C.") ✳

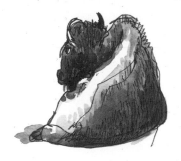

MICHELLE ✳

SAN FRANCISCO PUBLIC LIBRARY

MAIN BRANCH

in its own WORDS

PEOPLE LINE UP
OUTSIDE
BEFORE WE OPEN.

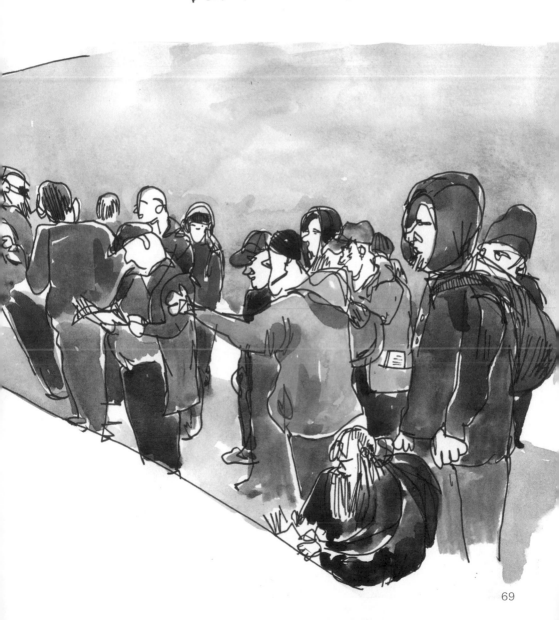

THE REGULARS COME IN QUIETLY,
SIT IN THE SAME PLACE EVERY DAY.

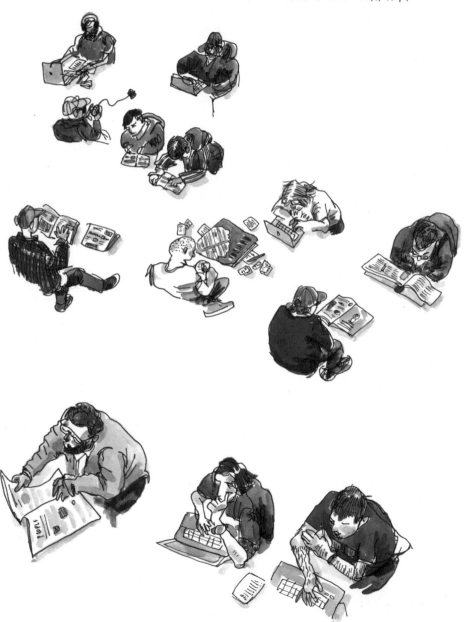

THEY HAVE THEIR ROUTINES.

COMPUTER

COMPUTER

COMPUTER

COMPUTER

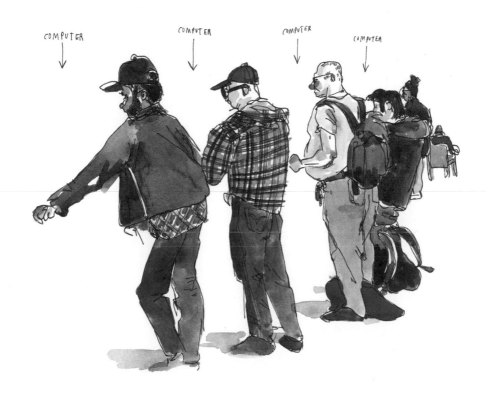

FLOOR "LL"

KORET AUDITORIUM
LIBRARY CAFE
JEWETT GALLERY
LATINO/ HISPANIC COMMUNITY MEETING ROOM
BATH- ROOMS

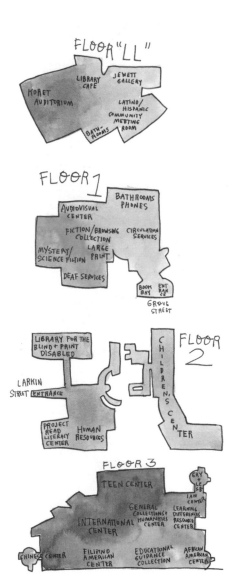

FLOOR 1

BATHROOMS PHONES
AUDIOVISUAL CENTER
FICTION/BROWSING COLLECTION
CIRCULATION SERVICES
MYSTERY/ SCIENCE FICTION
LARGE PRINT
DEAF SERVICES
BOOK BAY
ENTRANCE
GROVE STREET

FLOOR 2

LIBRARY FOR THE BLIND + PRINT DISABLED
CHILDREN'S CENTER
LARKIN STREET ENTRANCE
PROJECT READ LITERACY CENTER
HUMAN RESOURCES

FLOOR 3

TEEN CENTER
GAY + LESBIAN CENTER
GENERAL COLLECTIONS + HUMANITIES CENTER
LEARNING DIFFERENCES RESOURCE CENTER
INTERNATIONAL CENTER
CHINESE CENTER
FILIPINO AMERICAN CENTER
EDUCATIONAL GUIDANCE COLLECTION
AFRICAN AMERICAN CENTER

FLOOR 4

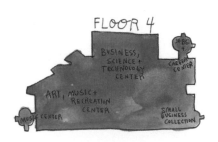

BUSINESS, SCIENCE + TECHNOLOGY CENTER
JOBS CAREER CENTER
ART, MUSIC + RECREATION CENTER
MUSIC CENTER
SMALL BUSINESS COLLECTION

FLOOR 5

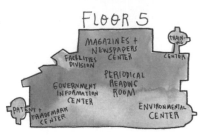

MAGAZINES + NEWSPAPERS CENTER
TRAIN- ING CENTER
FACILITIES DIVISION
PERIODICAL READING ROOM
GOVERNMENT INFORMATION CENTER
PATENT + TRADEMARK CENTER
ENVIRONMENTAL CENTER

FLOOR 6

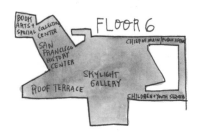

BOOK ARTS + SPECIAL COLLECTION CENTER
CHIEF OF MAIN PUBLIC AFFAIRS
SAN FRANCISCO HISTORY CENTER
SKYLIGHT GALLERY
ROOF TERRACE
CHILDREN + YOUTH SERVICES

72

FLOOR LL

LOUD, PEOPLE EATING, TALKING, DON'T HAVE TO PASS THROUGH SECURITY.

FLOOR 1

ROWDIEST, NOISIEST, MEDIA + INTERNET, BUSIEST.

FLOOR 2

SAFEST, A LOT OF CHILDREN + FAMILIES, HOMELESS ALREADY CONNECTED TO SERVICES.

FLOOR 3

INTERNATIONAL— LATINOS, ASIAN, FILIPINO. ALSO, PEOPLE GET TO THIS FLOOR + STOP. DON'T WANT TO WALK FURTHER.

FLOOR 4

A LOT OF REGULARS + PEOPLE DOING RESEARCH.

FLOOR 5

A LOT OF REGULARS READING MAGAZINES.

FLOOR 6

QUIET.

THIS LIBRARY MIRRORS
THE POPULATION WE HAVE IN SF.

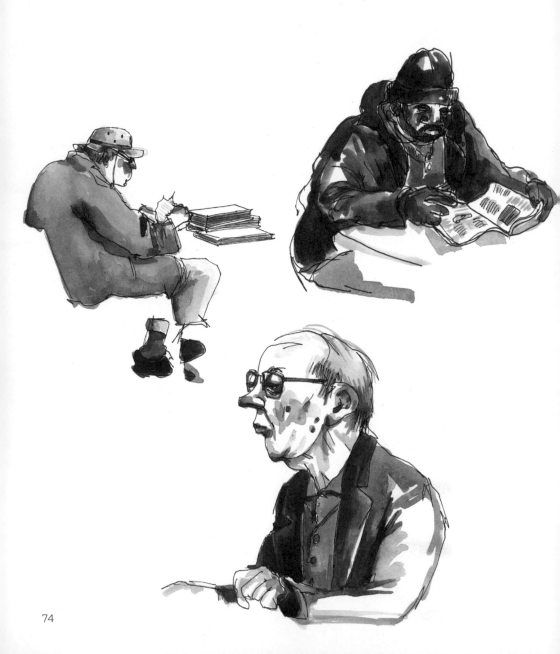

INTERNATIONAL

< Arabic
Chinese | Chinese >

< Chinese | Chinese >

< Chinese | Chinese >

< Chinese
Croatian
Czech | Dutch
Farsi
Filipino
French >

< French
German | German >

< German
Greek
Gujarati
Hebrew | Hindi
Italian
Japanese >

< Japanese | Japanese
Khmer
Korean
Polish
Portuguese >

< Portuguese
Punjabi
Russian | Russian >

< Russian | Russian
Serbian
Serbo-
Croatian
Spanish >

< Spanish | Spanish >

< Spanish | Spanish >

< Spanish
Swedish
Tamil
Thai | Thai
Ukrainian
Urdu
Vietnamese >

< Vietnamese | Vietnamese >

↓ RETURN ITEMS HERE ↓

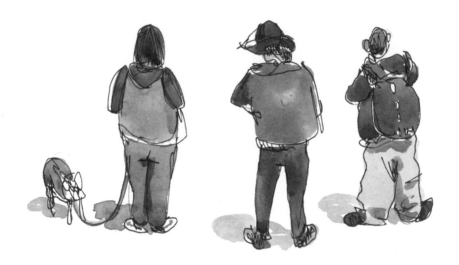

THE LIBRARY IS NOT JUST
AN INFORMATION CENTER.

IT'S ALWAYS BEEN A REFUGE for ANYONE to COME to, WHATEVER STATUS in SOCIETY. FOR PEOPLE, INTELLECTUALS, PSEUDO-INTELLECTUALS, for LONELY PEOPLE. FOR EVERY WALK of LIFE,

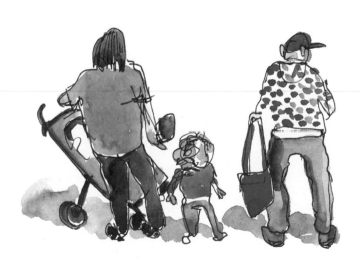

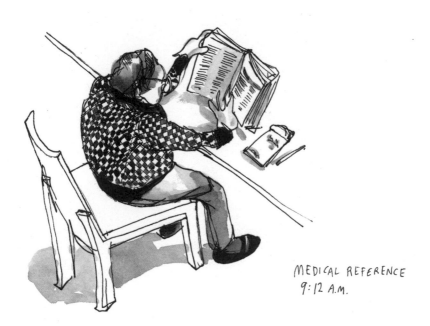

MEDICAL REFERENCE
9:12 A.M.

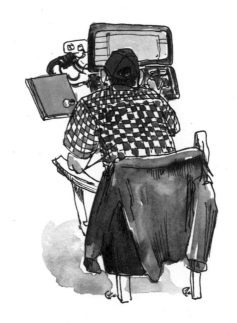

9:28 A.M.
LAPTOP TABLE

TO SIT DOWN NEXT TO EACH OTHER
EVERY DAY.

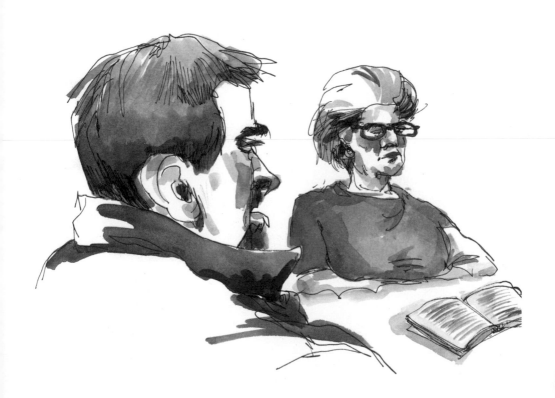

PEOPLE COME HERE
TO GET OFF
THE STREET.

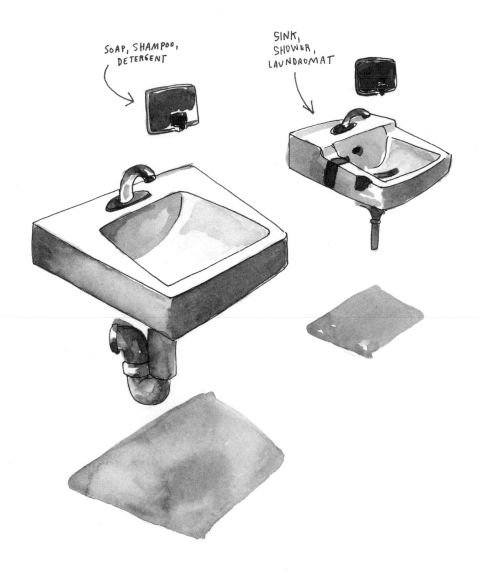

SOAP, SHAMPOO, DETERGENT

SINK, SHOWER, LAUNDROMAT

WE STARTED A HOMELESS OUTREACH TEAM
INSIDE THE LIBRARY.

LEAH

(FIRST AND ONLY FULL-TIME SOCIAL WORKER)
DEDICATED TO A LIBRARY, ANYWHERE.

WE HELP THEM FIND HOUSING,
GENERAL ASSISTANCE, OR SHELTER,
FREE EATS + SHOWERS + LAUNDRY.
THERE'S A JOB LAB WHERE NEWLY
HOMELESS CAN WRITE RESUMÉS
+ LOOK FOR A JOB.

CHARLES

(FORMERLY HOMELESS, NOW EMPLOYED
AS A HEALTH + SAFETY ASSOCIATE
AT THE SF PUBLIC LIBRARY'S MAIN BRANCH.)

ONE THING I'VE STOPPED SAYING HERE
IS "NOW I'VE SEEN IT ALL."

"D"
———
(GUARD)

ALL THE PEOPLE THAT ENTERED THE LIBRARY BETWEEN 12:45 P.M. – 12:50 P.M.

1. MAN WITH BURSTING BACKPACK
2. MAN WITH VEST + MATCHING COLLAR
3. ANDROGYNOUS PERSON IN BLACK SWEATSHIRT
4. WOMAN IN HER 20s WITH (SEE #5)
5. WOMAN IN HER 20s WITH (SEE #4)
6. MAN IN HIS 40s NOT WITH (SEE #7)
7. MAN IN HIS 40s NOT WITH (SEE #6)
8. MAN WITH A HAT
9. OLD MAN BENT OVER, BEARD NEARLY TOUCHING THE GROUND
10. YOUNG GIRL
11. ✳
12. ✳
13. MAN IN JEAN JACKET + SUNGLASSES
14. MAN WITH PLASTIC BAG
15. ✳
16. ✳
17. MAN WITH A BOX TOO BIG TO BRING INSIDE
18. MAN W/ A MESSENGER BAG + WALKIE TALKIE + NEON ORANGE TAPE
19. WOMAN IN ALL YELLOW SWEATS
20. MAN W/ BACKPACK + NEWSPAPER
21. WOMAN IN GREEN JACKET
22. MAN W/ BIKE HELMET + A SWAGGER
23. MAN W/ A DUFFLE BAG
24. MAN IN ALOHA SHIRT + SUNGLASSES
25. ✳
26. MAN IN A BLUE SWEATSHIRT
27. MAN IN TIGHT V-NECK, TIGHT JEANS, AND SHINY HAIR

28. ✳
29. ✳
30. WOMAN IN HAT WITH SCARF
31. ✳
32. ✳
33. ✳
34. ✳
35. ✳
36. ✳
37. ✳
38. WOMAN IN HAT
39. ✳
40. ✳
41. MAN IN STRIPED SHIRT + FLIP FLOPS
42. WOMAN WITH A PURSE SHE'D CALL A BAG
43. MAN IN ALL BLACK, BLACK JEANS, LOTS OF KEYS LIKE A STAGEHAND
44. YOUNG WOMAN WITH TIGHT T-SHIRT THAT SAYS SOMETHING
45. OLD WOMAN IN A KAFTAN
46. ✳
47. YOUNG, TALL MALE JOCK
48. ✳
49. ✳
50. HAVEN'T I SEEN HIM BEFORE?
51. ALL BLACK W/ A NEON GREEN BOTTLE (MAN)
52. GLASSES, HAIR-A-MESS, AMOEBA BOOKBAG (MAN)
53. MAN WITH DKNY BLAZER
54. GLASSES, ARGYLE, BOAT SHOES (MAN)
55. ALL NAVY SAVE FOR WHITE SOCKS + A TAN (MAN)
56. OLD MAN W/ FISHING HAT + CANE
57. ✳
58. ✳
59. RAY-BANS, LOOSELY + CASH. (MAN)

✳ = PEOPLE WHO MOVED TOO QUICKLY FOR ME TO TAKE NOTES ON

IF IT EXISTS,
WE HAVE IT.

IF WE DON'T,
WE'LL FIND IT.

ASK AND WE WILL ANSWER.

AND IT'S FREE.

MEANWHILE... **MISSION**

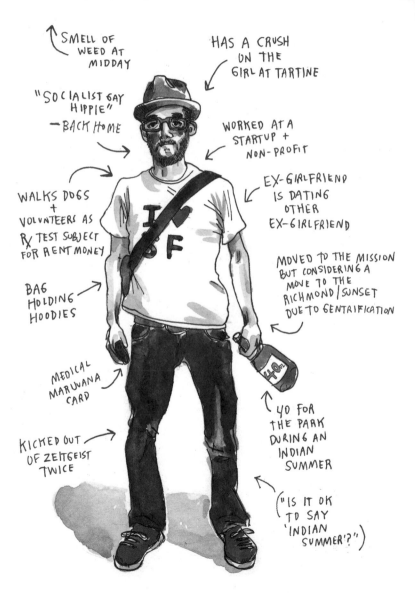

SMELL OF WEED AT MIDDAY

HAS A CRUSH ON THE GIRL AT TARTINE

"SOCIALIST GAY HIPPIE" — BACK HOME

WORKED AT A STARTUP + NON-PROFIT

WALKS DOGS + VOLUNTEERS AS Rx TEST SUBJECT FOR RENT MONEY

EX-GIRLFRIEND IS DATING OTHER EX-GIRLFRIEND

MOVED TO THE MISSION BUT CONSIDERING A MOVE TO THE RICHMOND/SUNSET DUE TO GENTRIFICATION

BAG HOLDING HOODIES

MEDICAL MARIJUANA CARD

40 FOR THE PARK DURING AN INDIAN SUMMER

KICKED OUT OF ZEITGEIST TWICE

("IS IT OK TO SAY 'INDIAN SUMMER'?")

HIPSTERS

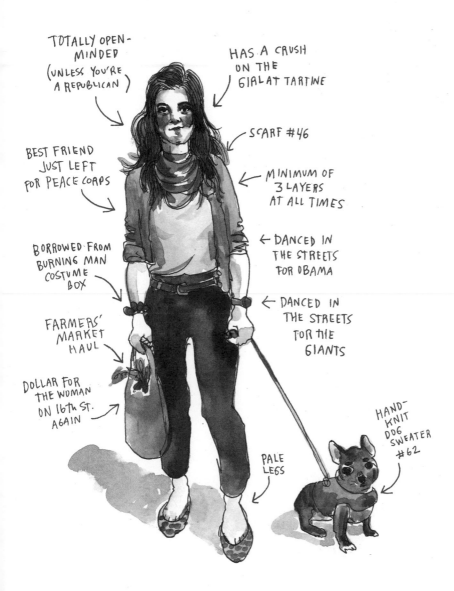

TOTALLY OPEN-MINDED (UNLESS YOU'RE A REPUBLICAN)

HAS A CRUSH ON THE GIRL AT TARTINE

SCARF #46

BEST FRIEND JUST LEFT FOR PEACE CORPS

MINIMUM OF 3 LAYERS AT ALL TIMES

BORROWED FROM BURNING MAN COSTUME BOX

DANCED IN THE STREETS FOR OBAMA

DANCED IN THE STREETS FOR THE GIANTS

FARMERS' MARKET HAUL

DOLLAR FOR THE WOMAN ON 16th ST. AGAIN

HAND-KNIT DOG SWEATER #62

PALE LEGS

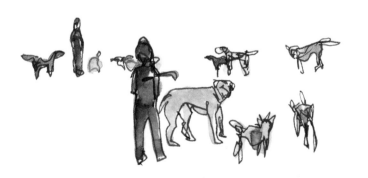

DOG WALKERS
in THEIR OWN WORDS

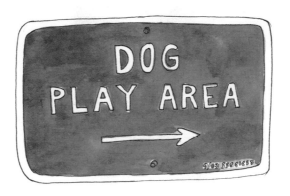

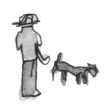

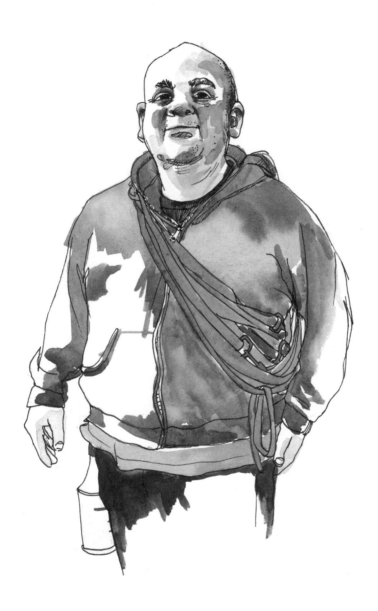

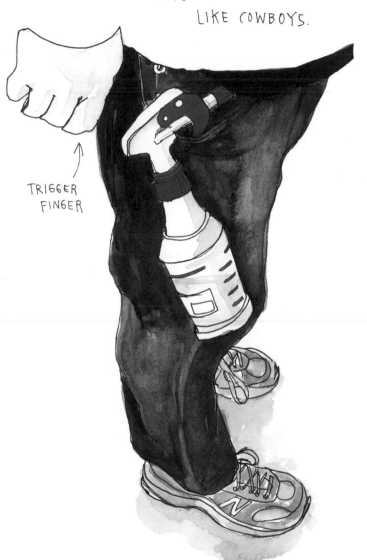

DOG WALKERS
ARE
LIKE COWBOYS.

TRIGGER
FINGER

○ **OFF LEASH DOG AREA** ○

YOUR NEIGHBORS AND THE RECREATION AND
PARK DEPARTMENT APPRECIATE RESPONSIBLE
DOG OWNERSHIP.

PLEASE
● NO MORE THAN SIX DOGS WALKED AT ANY ONE TIME
○ MUST HAVE ONE LEASH FOR EACH DOG
○ PICK UP AND REMOVE DOG WASTE
○ EACH DOG MUST WEAR A CURRENT DOG LICENSE
 AND IDENTIFICATION TAG
○ PREVENT DIGGING AND DESTRUCTIVE BEHAVIOR
THANK YOU ○
 HEALTH CODE 40 A, B & C, 41, 15 A
 PARK CODE SECTION 3 02

YOU NEED TO WATCH THE DOGS,
PICK UP POOP,
BE PATIENT AND KIND,

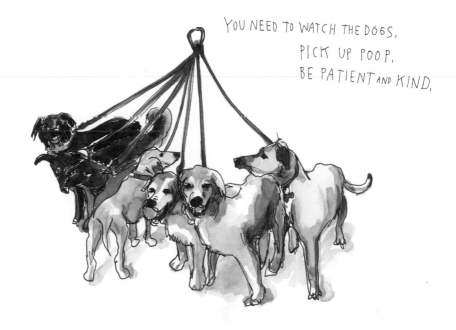

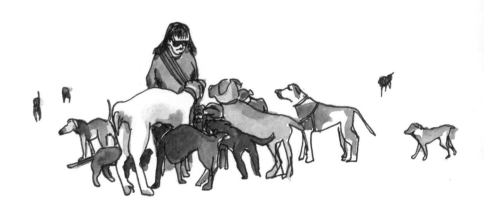

and
REALLY LOVE DOGS.

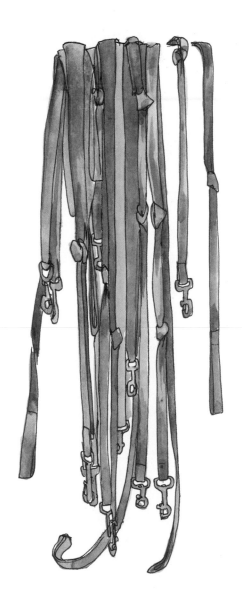

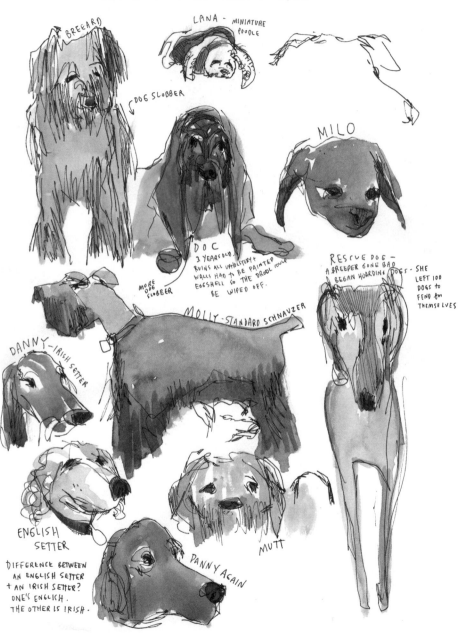

I DON'T KNOW ANY of THE OWNERS NAMES,
BUT I KNOW ALL THEIR DOGS...

BREEARD

LANA - MINIATURE POODLE

DOG SLOBBER

MILO

DOC
3 YEARS OLD,
RUINS ALL UPHOLSTERY +
WALLS HAD TO BE PAINTED
EGGSHELL SO THE DROOL COULD
BE WIPED OFF.

MORE DOG SLOBBER

RESCUE DOG -
A BREEDER GONE BAD
BEGAN HOARDING DOGS - SHE
LEFT 100
DOGS TO
FEND for
THEMSELVES

MOLLY - STANDARD SCHNAUZER

DANNY - IRISH SETTER

ENGLISH SETTER

DIFFERENCE BETWEEN
AN ENGLISH SETTER
+ AN IRISH SETTER?
ONE'S ENGLISH.
THE OTHER IS IRISH.

DANNY AGAIN

MUTT

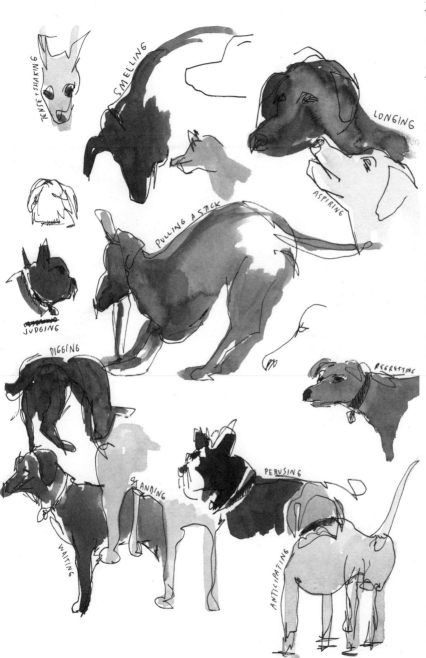

TENSE & SHAKING

SMELLING

LONGING

ASPIRING

PULLING A STICK

JUDGING

DIGGING

REGRETTING

STANDING

PERUSING

WAITING

ANTICIPATING

POOH
SAM
TATTOO
KOJAK
CHEYENNE
PRINCESS
COCO
TINY
FRISBEE
DOLLIE
ZOE
BUTCH
PICKLE
MILO
OMAHA
NUGGET
SHRIMP
FRISCO
JOKER
WINSTON
NACHO
DRAM
RIDLEY
LOLA
PEACOCK
PEPPER
DOC
LADY
ELI
LUCKY
GINGER
SOPHIE
BULL
PEE WEE
TROUT
SIERRA
MORGAN FAIRCHILD
LUCY
CHEWEY
CODY
BEAR
ROXY
VIOLET
DUKE
MAX

DOGS ARE LIKE KIDS—
THEY JUST WANT LOVE.

WHERE'S YOUR DOG?

MEANWHILE...

SPANISH RICE

ALUMINUM FOIL

BEANS

REFRIED or...

BLACK PINTO

MOSTLY

"WE MAKE ABOUT
200 GALLONS·
EVERY TWO DAYS"

GUACAMOLE

SOUR CREAM

PEOPLE COME *from* ALL OVER THE WORLD
for THIS- *from* SPAIN, GERMANY, CHINA...

FRANCISCO
RITO

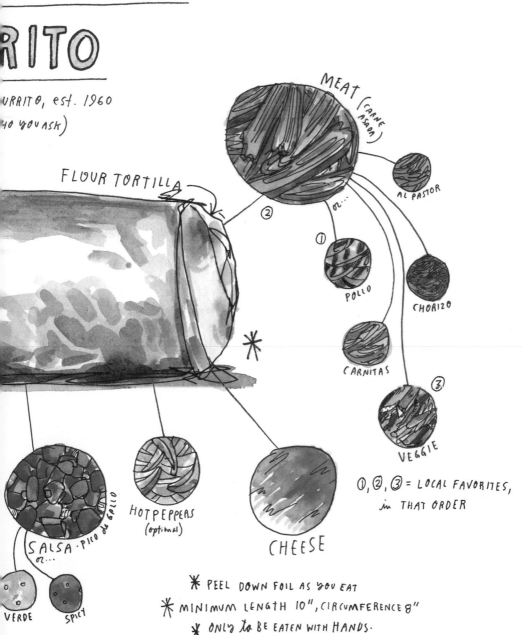

URRITO, est. 1960
(…o you ask)

FLOUR TORTILLA

MEAT (CARNE ASADA)

AL PASTOR

② or…

① POLLO

CHORIZO

CARNITAS

③ VEGGIE

①, ②, ③ = LOCAL FAVORITES, in THAT ORDER

HOT PEPPERS (optimal)

CHEESE

SALSA · PICO de GALLO
or…

VERDE SPICY

* PEEL DOWN FOIL AS YOU EAT
* MINIMUM LENGTH 10", CIRCUMFERENCE 8"
* ONLY to BE EATEN WITH HANDS.

SIXTH STREET

IN ITS OWN WORDS

6th St. ←

5th St. →

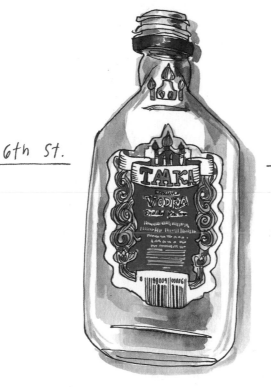

I CAME HERE IN 1968.

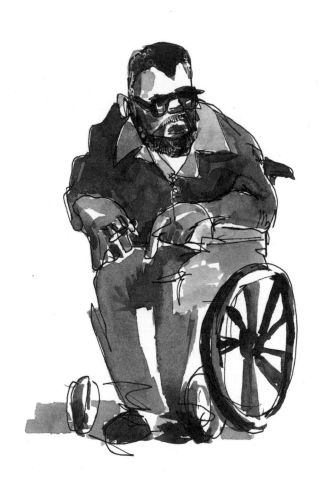

MOST PEOPLE WHO LIVED ON 6TH STREET
WERE MERCHANT MARINES, DAY LABORERS,
and MIGRANT WORKERS.

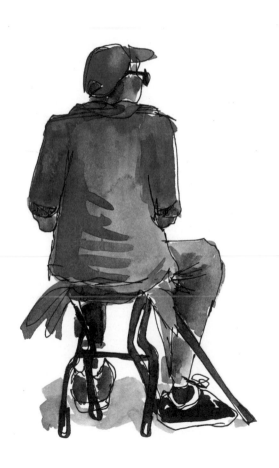

IT WAS A WORKING CLASS NEIGHBORHOOD.

IT TAKES A HUGE AMOUNT of ENERGY
TO LIVE ON 6TH STREET.

EVERYONE GOES to WORK.
to HUSTLE.

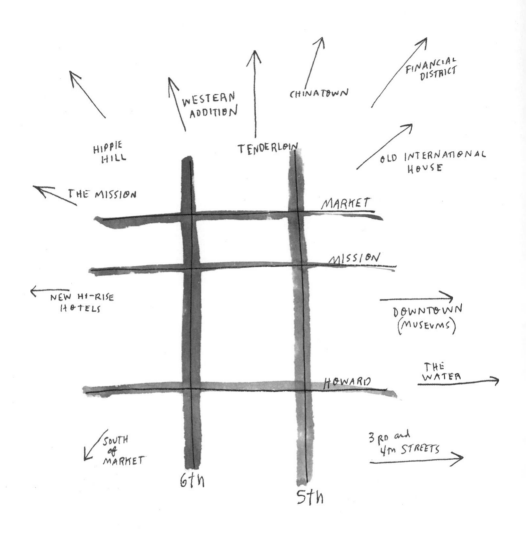

HIPPIE
HILL

WESTERN
ADDITION

TENDERLOIN

CHINATOWN

FINANCIAL
DISTRICT

OLD INTERNATIONAL
HOUSE

THE MISSION

MARKET

MISSION

NEW HI-RISE
HOTELS

DOWNTOWN
(MUSEUMS)

THE
WATER

HOWARD

SOUTH
of
MARKET

3RD and
4TH STREETS

6th

5th

"THE
HINGE"

(DOES NOT FALL
WITHIN ANY NEIGHBORHOOD LINES)

THERE WERE 40,000 UNITS DEMOLISHED BETWEEN
3rd and 5th STREETS in THE 50s and THE 60s.
NOBODY KNOWS WHERE THEY WENT.
SOME PEOPLE MOVED to 6th STREET.
IN THE LATE 70s THE OLD INTERNATIONAL
HOUSE HOUSED HUNDREDS of FILIPINOS. THEY
WERE EVICTED. THE SHERIFF CAME IN and
DRAGGED THEM OUT. THE OWNER DEMOLISHED IT
and LEFT IT A BIG HOLE in THE GROUND.
A LOT of THOSE FILIPINOS CAME to 6th STREET.
WESTERN ADDITION SROS WERE KNOCKED DOWN
and THOSE PEOPLE MOVED HERE, too.

SENECA HOTEL

HENRY HOTEL

CHRONICLE HOTEL

THE WHITAKER HOTEL

MIDTOWN LOAN 39

SUNNYSIDE HOTEL
REASONABLE RATES

ST. CLOUD HOTEL 170 6TH ST.

HOTEL ALDER

Fred's LIQUOR & DELI
Coca-Cola

SUNSET HOTEL 161

THE ROSE

THE DUDLEY

BALDWIN HOUSE HOTEL
- CLEAN ROOMS
- REASONABLE RATES
- DAILY, WEEKLY, MONTHLY

WHEN I MOVED HERE THERE WERE
40 PEOPLE IN THE HOTEL.

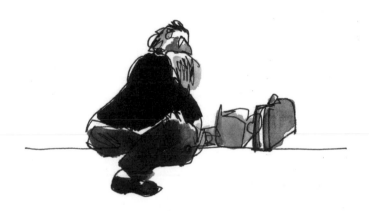

NOW THERE ARE 300.

(THE BIGGEST PINCHER BUG I'VE EVER SEEN.)

ACTUAL SIZE

THIS IS A RESIDENTIAL NEIGHBORHOOD.

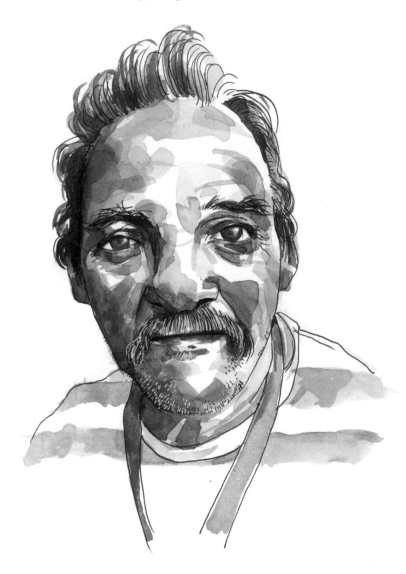

THIS IS OUR FRONT PORCH.

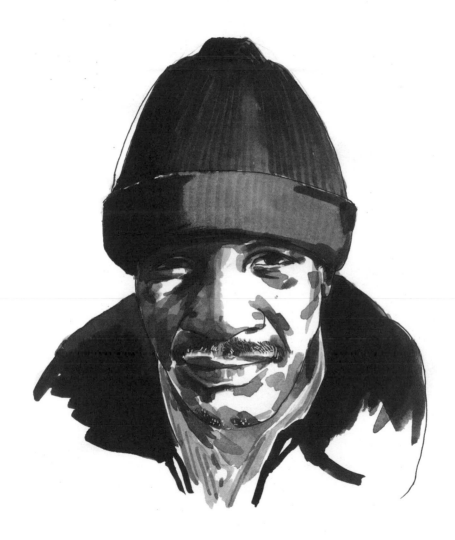

THIS IS OUR FRONT YARD.

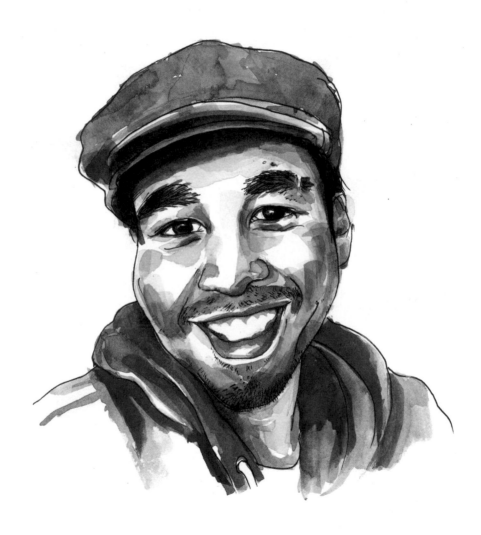

I'M <u>NOT</u> TRYING TO GET OUT of HERE.

PEOPLE HANG ON THE STREET NO MATTER WHAT.

RAIN, SNOW, and SLEET.

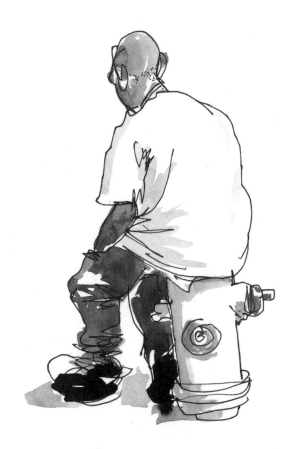

I KNOW EVERYONE.

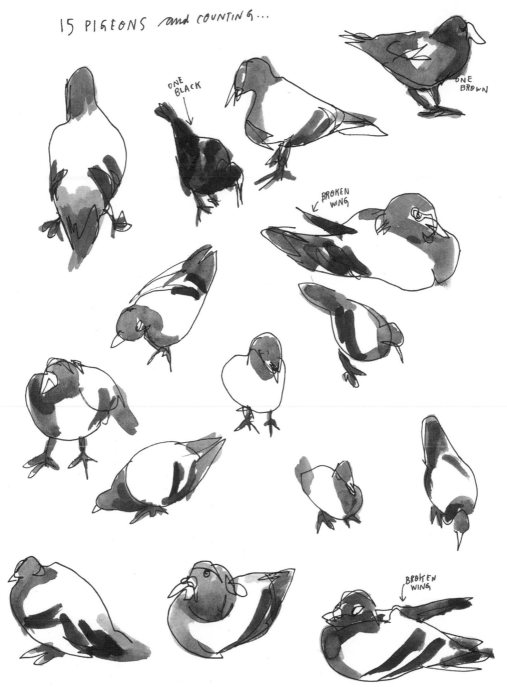

15 PIGEONS and COUNTING...

ONE BLACK

ONE BROWN

BROKEN WING

BROKEN WING

123

OVERHEARD @ THE CORNER of
5th and MISSION — 5 MINUTES

LIKE 4 O'CLOCK-ISH

I DON'T KNOW IF GLORIA IS COMING

YOU ALREADY KNOW WHAT IT IS YOU NEED

THE BENEFIT of CONVERSATION

I THINK I NEED THAT, BUT WHATEVER

ONE DAY OUT of THE HOUSE IS ENOUGH for ME

YOU COULD GET THAT ONE

A TIME WHEN I WAS TRYING to PAY INTO FUEL

SPOTTY WIRELESS

SO MY iPHONE DIED

SO BUSY

HE HAD THIS HYSTERICAL COMMENT

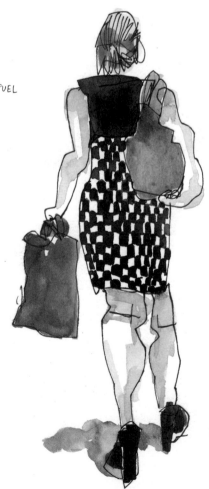

OVERHEARD @ THE CORNER of
6th and MISSION - 5 MINUTES

I DON'T KNOW MAN *
HEY HEY HEY HEY *
HI *
MOST of THEM DEAD GONE
HELLO THERE *
BEAUTIFUL LADY YES YOU ARE *
HEY I SAW YOU EARLIER. WHAT ARE YOU WRITING? *
YEAH I'M GOING THERE. NOT NOW.
WELL, HELLO. *

* DIRECTED to THE ARTIST.

THERE ARE FOUR TYPES of PEOPLE on 6TH STREET:

1. PEOPLE WHO LIVE IN SROs

2. PEOPLE WHO SLEEP IN A SHELTER and HANG OUT ON 6th STREET

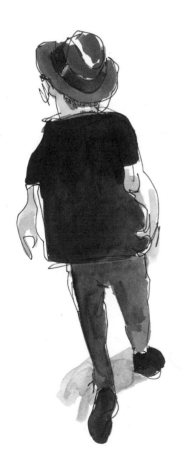

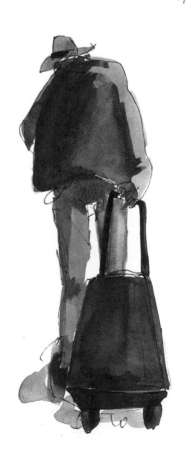

3. PEOPLE WHO WORK ON 6th STREET

4. PEOPLE WHO WALK THROUGH

THERE ARE FOUR TYPES of PEOPLE on 5th STREET:

1. PROGRAMMERS

2. TOURISTS

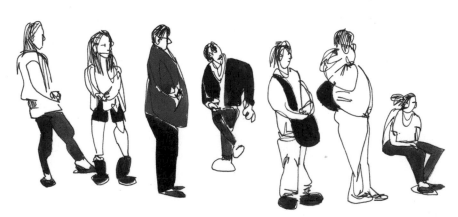

3. BUSINESS PEOPLE

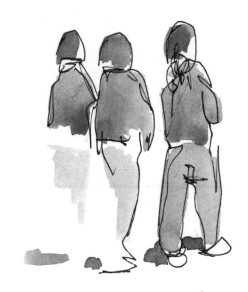

SOFTWARE DEVELOPERS OR
INTERNET MARKETERS
HEADING to A CONFERENCE.

4. AUSTRALIANS

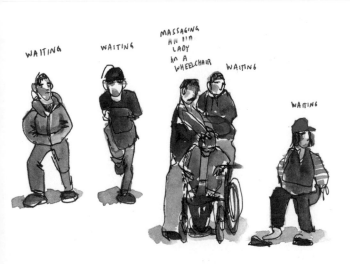

WAITING

WAITING

MASSAGING
AN OLD
LADY
IN A
WHEELCHAIR

WAITING

WAITING

WAITING
and
DANCING

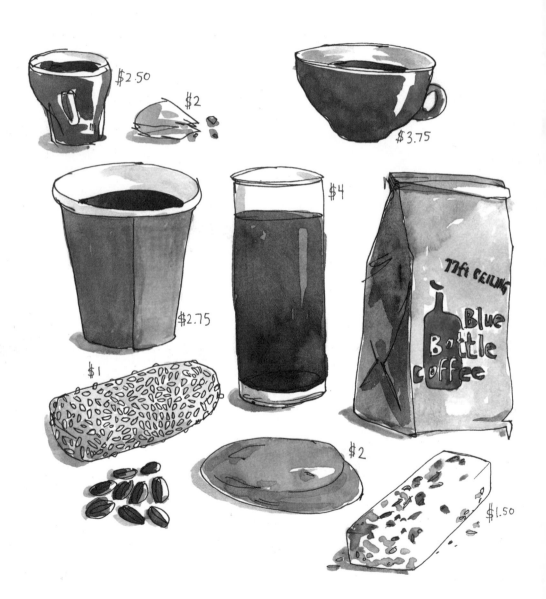

$2.50

$2

$3.75

$4

$2.75

$1

Blue Bottle Coffee

$2

$1.50

6th STREET

City Produce

DO YOU HAVE ANY FRUIT?
NO.
VEGETABLES.
NO.
ANY PRODUCE?
NO.
ANY PLACE ON 6th STREET?
NO. YOU HAVE TO GO AROUND THE BLOCK.

A BLOCK AWAY.

A UNIVERSE AWAY.

I DON'T THINK THIS PLACE
IS GOING TO BE AROUND MUCH LONGER.

IT'S VALUABLE REAL ESTATE.

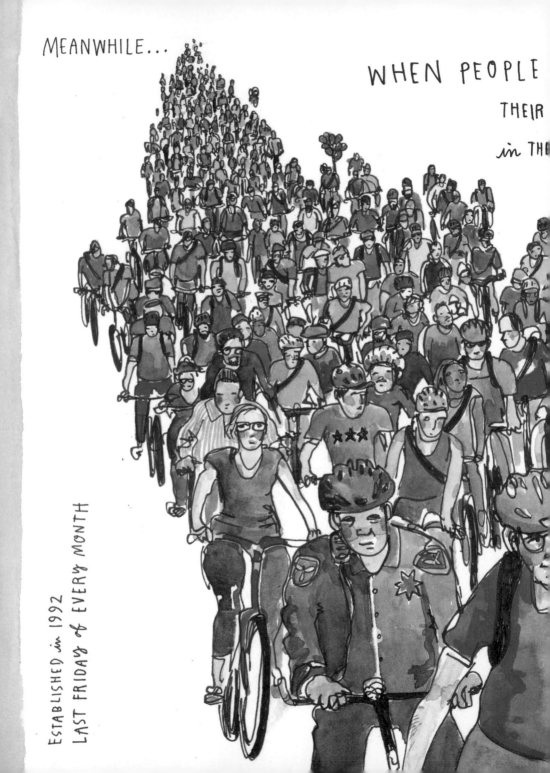

PARTICIPATE in **CRITICAL MASS**

INHABITATION of PHYSICAL SPACE IS ALTERED

MOMENT, in THE GHOST of THE PAST, and in

THEIR IMAGINATION.

IT'S A NEW UNDERSTANDING of HOW
A CITYSCAPE CAN FUNCTION,
and WHAT IT CAN
ACCOMODATE.

DOLPHIN CLUB

IN ITS OWN WORDS

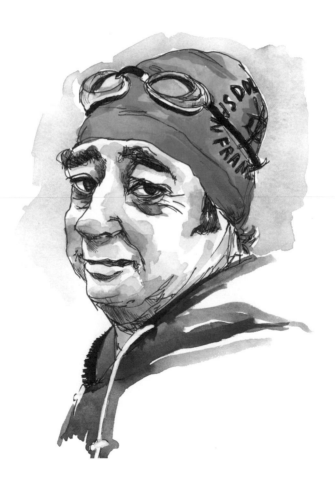

THIS PLACE

IS

SAN FRANCISCO.

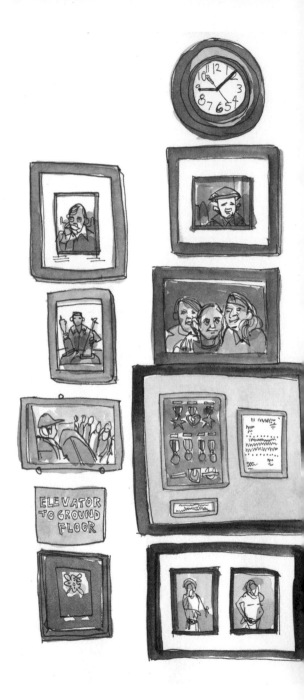

IN THE OLD DAYS,
MEN CAME HERE TO GET AWAY
FROM THEIR WIVES, SMOKE CIGARS,
AND LIE TO EACH OTHER.

DOLPHIN CREW, 1913-14-15

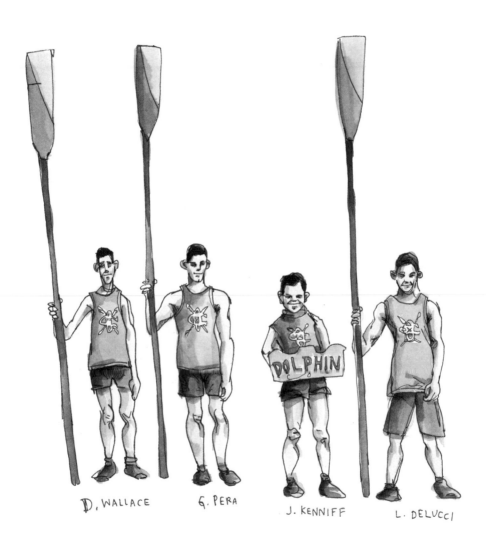

D. WALLACE G. PERA J. KENNIFF L. DELUCCI

BUT NOW,

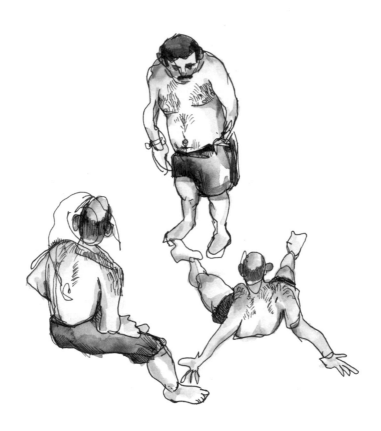

THE ONLY THING YOU HAVE TO BE IS

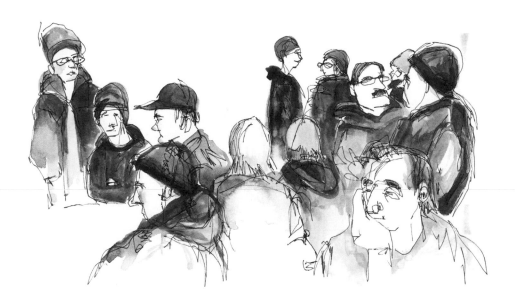

CRAZY ENOUGH

TO GET IN THE WATER.

GETTING IN THE WATER IS A TERRIBLE EXPERIENCE.

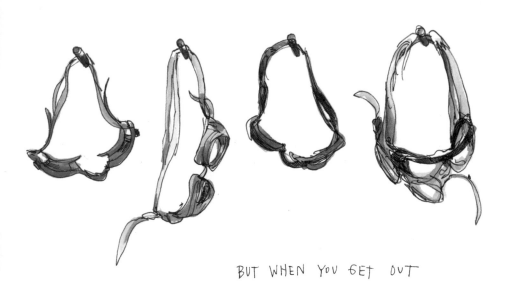

BUT WHEN YOU GET OUT

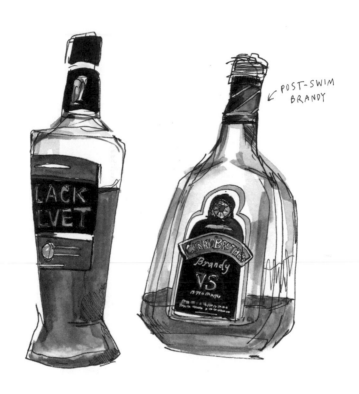

POST-SWIM BRANDY

THERE'S NOTHING LIKE IT.

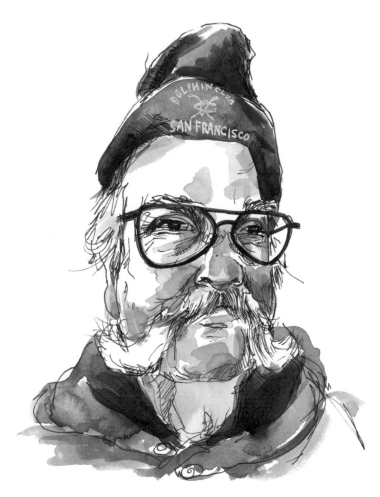

THE OLDTIMERS

THEY ARE ENGAGING
IN LIFE,

COCONUT
GOGGLES

NOT JUST
WATCHING.

COME ON.

GET IN THE WATER.

MEANWHILE...

SYMPHONY HALL

SCARF WEATHER:

TALLEST DOME in THE USA
FIFTH TALLEST in THE WORLD

CITY

BILL GRAHAM
CIVIC AUDITORIUM

GOLD LION
GOLD ALMOND
GOLD LEAFY DECOR →

MORE LIONS
ALL REAL GOLD

SF's CITY HALL WAS BUILT in TWO YEARS
(1913-1915) UNDER THE DIRECTION of MAYOR JAMES ROLPH. IT REPLACED THE
PREVIOUS CITY HALL THAT WAS DESTROYED by THE 1906 EARTHQUAKE.
LABORERS CAME from ALL OVER THE WORLD to HELP WITH THE BUILDING (AND
STAYED in TENTS SURROUNDING CITY HALL- IT WAS CALLED "TENT CITY?) IT WAS AN ECONOMIC
BOON for SAN FRANCISCO and HELPED MAKE SF THE HOME of
THE 1915 PANAMA-PACIFIC INTERNATIONAL
EXPOSITION. AKA, THE WORLD'S FAIR.

HOMELESS

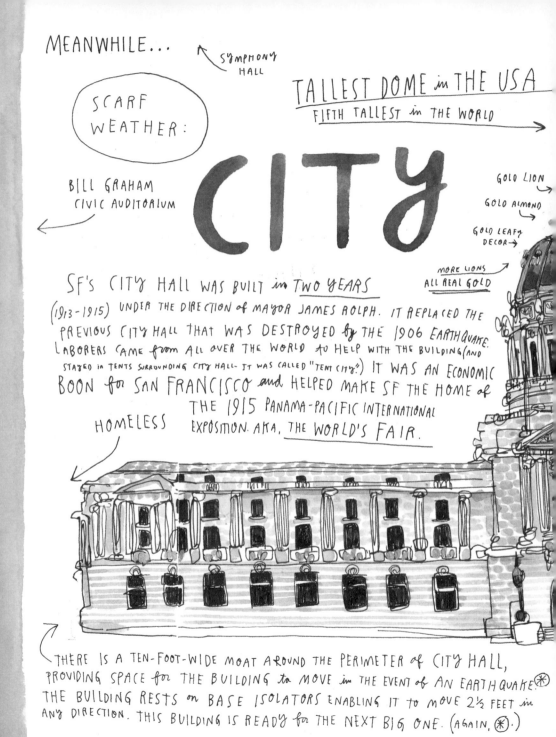

THERE IS A TEN-FOOT-WIDE MOAT AROUND THE PERIMETER of CITY HALL,
PROVIDING SPACE for THE BUILDING to MOVE in THE EVENT of AN EARTHQUAKE ✳
THE BUILDING RESTS on BASE ISOLATORS ENABLING IT to MOVE 2½ FEET in
ANY DIRECTION. THIS BUILDING IS READY for THE NEXT BIG ONE. (AGAIN, ✳.)

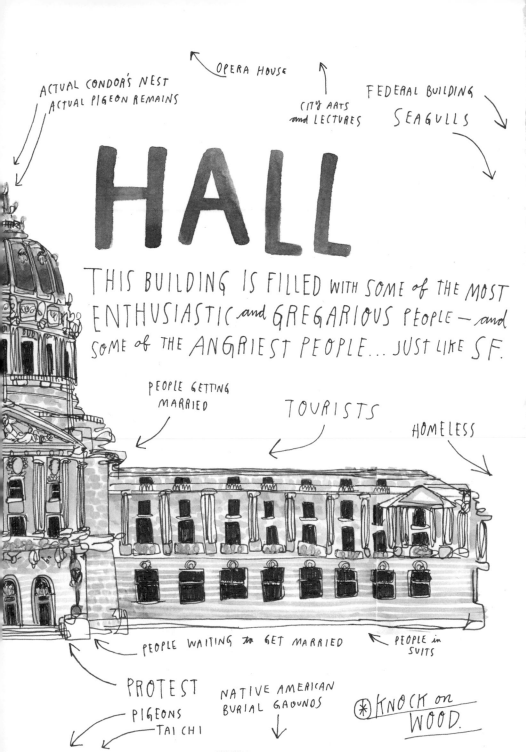

MAKERS

ARTISANS, CRAFTSPEOPLE, and DIY

IN THEIR OWN WORDS

WELDER
EXPLORATORIUM (OLD)
MACHINIST
BONSAI TREE TRIMMER
CERAMICS
RENEGADE CRAFT FAIRE
TOPIARY GARDENER
MOSAIC ARTIST
WEAVER
MILLINER
SOAP MAKER
BALLOON SHAPER
FABRICATOR
ARTIST STUDIOS
KNITTERS
SHOE MAKER
JEWEL
LIGHTING DESIGNER AND MANUFACTURER
QUILTMAKER
FRAMER
BAG MAKER
BLACKSMITH
GLASS BLOWER
CLOTHING DESIGNER
SF MADE
TEC
PRINTMAKER
ZINE MAKER
WORKSHOP
MAKESHIFT SOCIETY
WORK WEAR DESIGN
MAK
3 FISH STUDIO
POTTER
KNIFE MAKER
SIG PAIN
PAINTING
NEON SHOP
CHAIR MAKER
PAPER ARTIST
SHIRT MAKER
CREATIVITY EXPLORED
BUTTON MAKER
SURFBOARD SHAPING
PRINTSHOP
NOISEBRIDGE
ARTIST STU
THE WOODSHOP
JEWELRY MAKING
ARTISTS' STUDIOS
ENGINE WORKS
BAY AREA VIDEO COALITION
FURNITURE BUILDING
ILLUSTRATOR
CERAMICS
SF CENTER for THE BOOK
SKATEBOARD MAKER
BEAD WOR
MODEL MAKER
TEXTILE DESIGNER
LETTERPRESS STUDIO
GRAFFITI ARTIST
WOO
STAMP MAKER
SILVERSMITHING
HANDMADE ARTISANAL PET TOYS
BIKE BUILDER
SILKSCREENER'
SCULP
MASTER HOT ROD CUSTOM PAINTER
MURAL PAINTER
BU
FOUND-OBJECT ARTIST
CHAPBOOK PRINTER
KNITTER
COSTUME MAKER
LEATHER WORKER
BIRDHOUSE MAKER
CANDLESTICK MAKER
VIOLIN MAKER
CHICKEN COOP BUILDER

MAKER FAIRE ↓

158

CRUCIBLE

REET
RTISTS

RATORIUM
(NEW)

MAKERS

HOP | CRAFT WARES

SCOOTER BUILDER

ARTIST STUDIOS

THE
RKSHOP
SIDENCE

yCAT

BUILDING

G.
KER | BOAT

NITTER

KER | ARTIST STUDIOS

THING
DESIGNER

ER
DIOS

PEOPLE MAKE THINGS HERE.

A LOT of STUFF IS BEING MADE in CHINA
or ON A COMPUTER.

PEOPLE IDENTIFY WITH SOMETHING
MADE by HAND.

WE WANTED to MAKE STUFF,

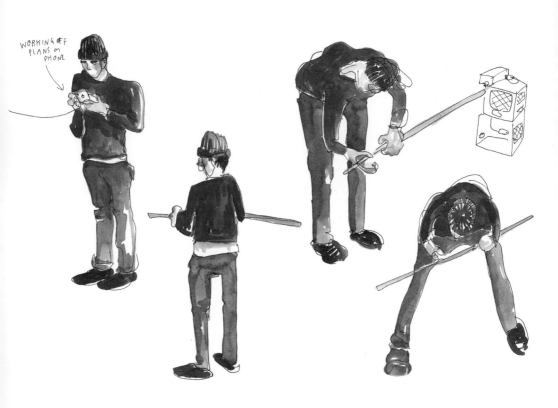

WORKING OFF PLANS ON PHONE

THEN GO SURF.

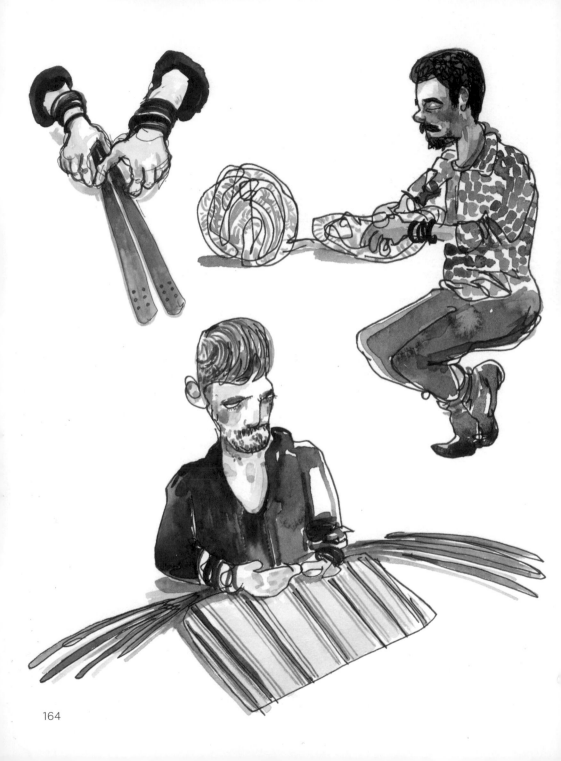

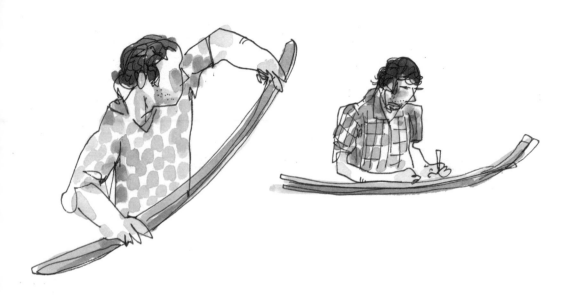

THERE'S THIS GROWING REVERENCE
for CRAFTSMANSHIP.

WE COLLABORATE *and* HELP PEOPLE OUT.

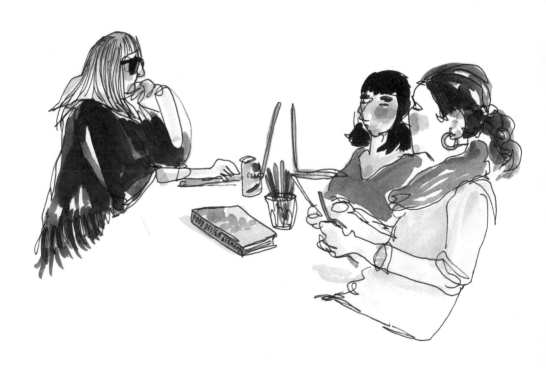

INSPIRATION
BOARD

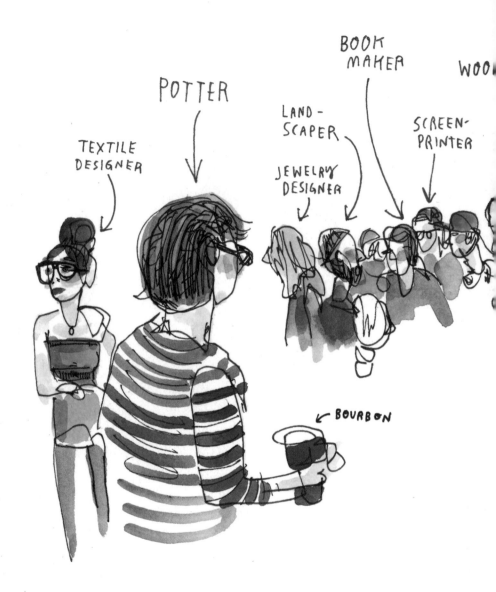

BOOK MAKER

WOO[

POTTER

LAND-SCAPER

SCREEN-PRINTER

TEXTILE DESIGNER

JEWELRY DESIGNER

← BOURBON

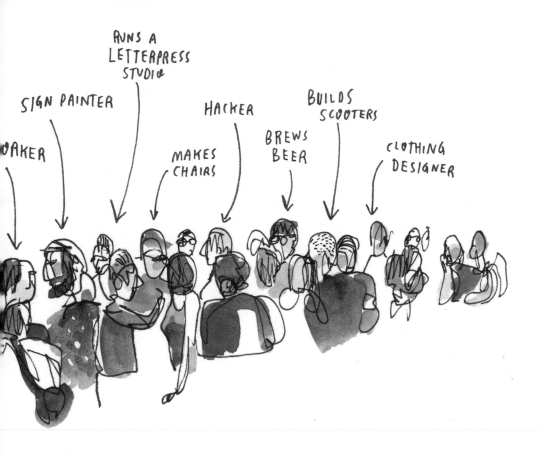

RUNS A
LETTERPRESS
STUDIO

SIGN PAINTER

HACKER

BUILDS
SCOOTERS

BAKER

MAKES
CHAIRS

BREWS
BEER

CLOTHING
DESIGNER

WE HAVE A CREATIVE CRUSH on EVERYONE HERE.

IF THIS SORT of ARTISTS' SPACE CAN EXIST in ONE of THE MOST EXPENSIVE CITIES in THE U.S.

IT CAN EXIST ANYWHERE.

MAKE SOMETHING.

WE SHARE
A SECRET.

ACKNOWLEDGMENTS

THANK you to ALL THE FOLLOWING PEOPLE WHO CONTRIBUTED THEIR TIME, THOUGHTS, WORDS, LIKENESS, and SUPPORT to THIS PROJECT.

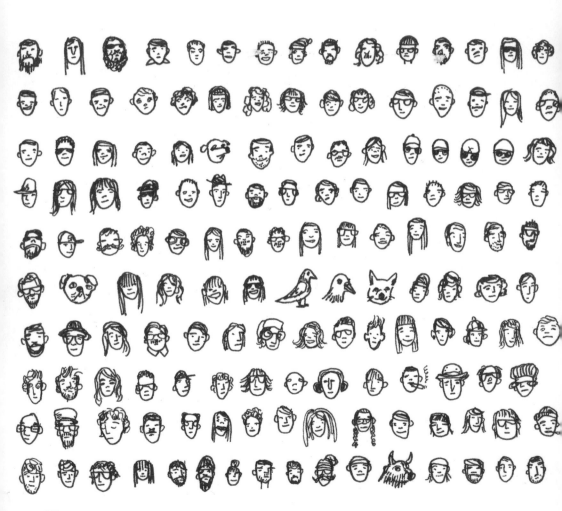